POSTCARD HISTORY SERIES

Hammonton

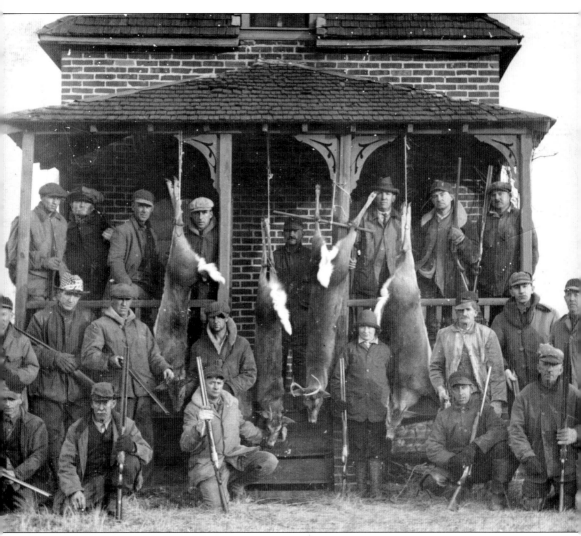

Hunting has always been an American pastime, and it was in Hammonton. This is one of its earliest hunting clubs. Notice the woman, Clara Hickman, at the right of the steps, proudly grasping her shotgun and holding her own among her fellow male hunters. Deer and rabbits supplemented the country dinner table in those days, a true help through the Great Depression when this photograph was taken.

POSTCARD HISTORY SERIES

Hammonton

Grayce Pitera and Kristin B. Colasurdo

ARCADIA
PUBLISHING

Published by Arcadia Publishing
Charleston SC, Chicago IL, Portsmouth NH, San Francisco CA

Printed in the United States of America

Library of Congress Catalog Card Number: 2008922974

For all general information contact Arcadia Publishing at:
Telephone 843-853-2070
Fax 843-853-0044
E-mail sales@arcadiapublishing.com
For customer service and orders:
Toll-Free 1-888-313-2665

Visit us on the Internet at www.arcadiapublishing.com

*First and foremost, we wish to dedicate this book to our families for
their support and input, which truly steadied the course for us. We also want
to dedicate this effort to all those who gallantly work to preserve the past.
The acts of collecting, documenting, and preserving artifacts are thankless,
time-consuming tasks. Many notable facts and treasured items would be lost
but for the diligence of historians, amateur and professional alike.
To all of you, we are truly thankful.*

CONTENTS

ACKNOWLEDGMENTS

No project is ever completed without much appreciated work and support from a behind-the-scenes group, as was the case with this book. First, of course, we wish to thank Arcadia Publishing for giving us the opportunity to publish this edition and our editor, Erin Rocha, for her expertise and undying patience. We also wish to thank fellow Historical Society of Hammonton members Janet Worrell, Jo Ahearn, Harry Coblentz, William H. and Catherine Parkhurst III, and president and general manager of Cape May Seashore Line Tony Macrie for adding insight in their areas of interest; the Historical Society of Hammonton for use of its postcard collection; Barbara Coia for her support; and Tom Chipp for the 1940s facts he remembered of his father, Rev. F. J. Chipp, and his Episcopal parish.

Conversations about years past with town historian Joseph Wilson, now deceased, were invaluable to this project. We are grateful for overall information from the study of Hammonton Lake by Kathy Sedia of Richard Stockton College for the New Jersey Department of Environmental Protection, *Through the Eyes of Joseph Wilson* by Donna Wilson Brown and Hammonton Middle School students, the 1930s federal government study *Italians on the Land* by sociologist Emily Fogg Meade, the September 1945 edition of *Columbus Magazine*, the 1889 *Illustrated History of the Town of Hammonton*, and various published 1950s Hammonton Chamber of Commerce pamphlets. Most of all, our appreciation goes to Pat and Sandy Onofrio, who literally gave us carte blanche use of two mammoth postcard collection books from their personal archives and allowed us to publish many of the cards in this book.

INTRODUCTION

Hammonton was incorporated in 1866 as a tiny village. It soon became a town of small proportions and slowly grew to reach its present population of 13,000. In comparison to urban cities, it is still a small community. It has been and will forever be a small, proud town shouting the old adage that large is not necessarily better. It is, by its own admission, a prosperous town. Hammontonians know how to live. Their lifestyles always include people, travel, and neighborly interest in everyone they meet. They play hard, work hard, and live life to its fullest.

Plunked down in the middle of the New Jersey Pine Barrens, much of the town's ground is government protected, where development is strictly regulated. While its size is written, its virtual population tends to remain the same even though new people move within its borders to enjoy the rare urban-country lifestyle the residents have established. There is a reason for that.

Many Hammontonians own homes in Florida; others have homes at the shore. Even if its population grows, Hammonton is a hometown abandoned for a few months a year by a large number of its townspeople. Its citizenry enjoys summers at the shore, winters in the South, cultural arts, sports, and the freedom to enjoy life's bounty of treasures.

One other distinction is ever present. Hammontonians' love for their town is fierce. They prefer to stay here and work for what they would like to see the town become rather than move to another area that has already established their desired way of life. That one notion keeps Hammonton a lively town from within.

In spite of its small size, the town has managed to host churches of all religious denominations, quietly sustain many thriving ethnic groups, be home to national figures, become the source of a 1930s government study by famed sociologist Emily Fogg Meade, host an art colony in the early 1900s, sustain two railroads, produce the 1949 Little League world champions, be hailed as a health resort in 1905, harbor a major clothing industry, provide two heralded school systems (public and parochial), and be visited by important figures, such as Pres. Theodore Roosevelt, John Philip Sousa, and Pres. Ronald Reagan. The list goes on.

The town was settled by groups of New England farmers. Eventually they sent a plea to Sicily asking for temporary help. The Sicilians answered the call. Within a short time, the immigrants sent for their families. The Italian ladies admired their new American friends and soon began to adopt many of their ways. They adapted their New Englander neighbors' recipes and borrowed their home-decorating styles.

In some ways both groups were naturally alike, the most obvious being their commitment to frugality. They also built homes with similar architectural features such as two floors, two rooms deep with gable roofs.

Hammontonians became a peculiar mix of Yankee staidness and Italian gregariousness, resulting in a very distinctive populace found nowhere else in the country. The town works at maintaining its provincial ways while still keeping up with the contemporary world.

The overall landscape has changed very little. Most of the downtown buildings are the very same buildings of the late 1800s. Certainly there have been those who renovated and updated, not always wise decisions, but the top exteriors still proudly stand as reminders of the era in which they were created. All one has to do is look up to study the history of the town's business section.

Hammonton Lake, Bellevue Avenue, and Central Avenue were part of the original town blueprint. The public school came as an early addition to which all the outlying one-room country schoolhouses eventually closed their doors and sent their students.

Hammonton is located midway between Philadelphia and Atlantic City. In one day, Hammontonians may see a New York City Broadway play, visit the Liberty Bell, ski in the mountains, enjoy the beach, frequent the casinos, or cheer national sports teams in New Jersey, Philadelphia, or New York and return to their homes in the same evening.

It has earned many nicknames in its time. The two most well known are "the Hub of South Jersey" and "Blueberry Capital of the World." The U.S. Census Bureau declared it to be the American town with the largest Italian population at the beginning of the 21st century. It is a town that loves to party, squabble, forgive, forget, and behave like one big family. It offers respect, love, and camaraderie to its townspeople. It is home, a place one cannot wait to leave as a youth but happy to return to later raise kids, and the process starts all over again.

All that may be seen on the face of these postcards, but the messages they carried were a different story. They cheered the sick, consoled the bereaved, and congratulated the newlyweds. They asked about a sister's health, a friend's job, and a nephew's school. They invited friends to visit or to attend a birthday party. They gifted students as a token from their teachers. Postcards did all that for only pennies out of one's pocket.

Such postcards of a town at a time when it enjoyed a population of less than 5,000 townspeople say a lot about Hammonton's leaders who saw the importance of heralding their community to others. Books were written about the health benefits of the Hammonton Lake waters, clean air, and pine trees. The soil was perfect for farming. The climate was moderate, enjoying a bit of all four seasons. They had a good thing, and they wanted to glorify it. These small, inexpensive postcards did the trick, finding their way back into private collections.

This collection is an example of this small town's conception of itself as a major destination. Postcards were products designed for major cities and tourist attractions. Hammontonians were not intimidated by that fact. They saw themselves as cosmopolitan as any New Yorker, so they went the distance.

They loved their town and managed it as if it was a big city, a trait that is still within the town limits. This book holds only a small number of the postcards printed of scenes of Hammonton.

We hope you enjoy these cards as much as we enjoyed selecting them. This was a thrilling project for us, one that offered us much information about the past townspeople and their habits. Postcards document the lifestyles of those early days. While they were only worth pennies in their heyday, and some are faded just a bit, they are priceless today.

So sit back and transport yourself to another era. Imagine yourself somewhere in the center of each postcard, and you will be experiencing the quintessence of a magical journey through the world of Hammonton in vintage postcards.

One

A PLACE TO STAY

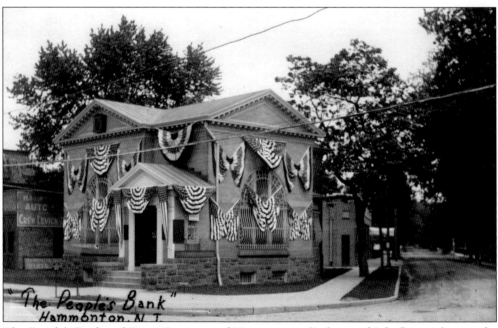

"The People's Bank"
Hammonton, N. J.

The People's Bank and Trust Company of Hammonton displays multiple flags and swags for a local event worth celebrating, most likely Hammonton's annual Fourth of July celebration. Situated on the corner of Central and Bellevue Avenues with an automobile dealership as its neighbor, the bank held a commanding presence. Metal bars at its windows ensured patrons that their deposits were secure.

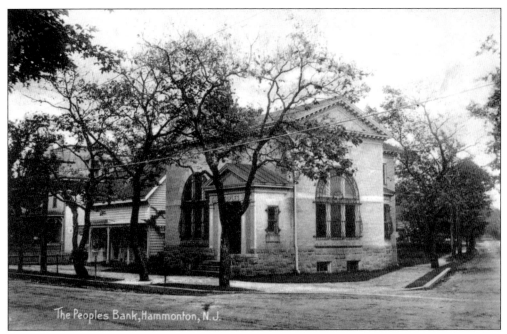

The Peoples Bank, Hammonton, N.J.

In the 1800s, it was not unusual to see nicely designed public buildings such as this original People's Bank and Trust Company of Hammonton structure situated directly next door to an ordinary home. This home later became the automobile dealership noted on the previous page. The young town was forming, and its downtown was still establishing itself. Consequently, the result was incongruous architecture that was typical of the times.

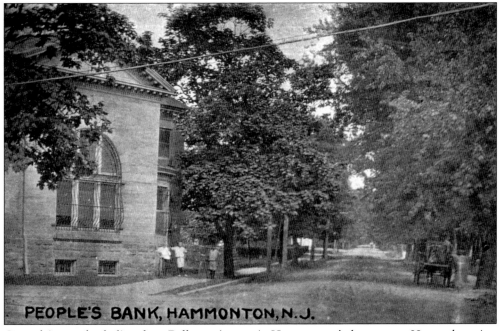

PEOPLE'S BANK, HAMMONTON, N.J.

Central Avenue leads directly to Bellevue Avenue in Hammonton's downtown. Here a charming view of the original bank, flanked by natural greenery, sets the tone for this photograph—one of prosperity and order.

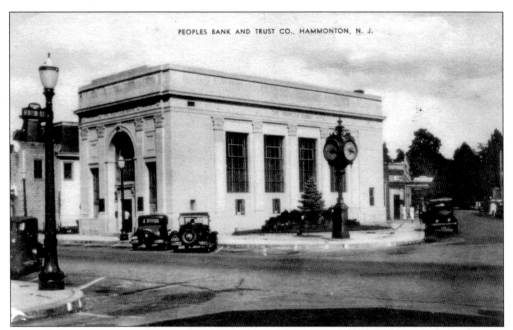

The addition of the Seth Thomas clock at the corner of Central and Bellevue Avenues was cause for great celebration. It was the first monument of its kind in the area and a source of pride for the townspeople. Later when moved to its present Central Avenue location, it suffered slight damage to its ornate casing, which was later repaired.

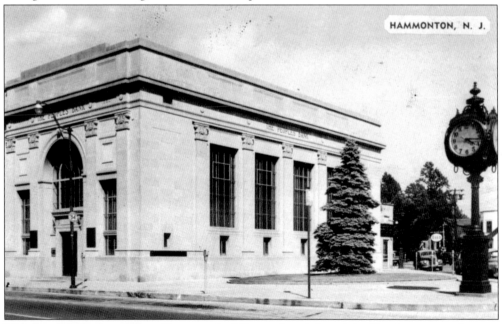

HAMMONTON, N. J.

This People's Bank and Trust Company building replaced the original bank structure that was considered a landmark of its time. The original structure was moved a block off Bellevue Avenue to Central Avenue and Vine Street. There it became the new home of Hammonton's town hall and police department. In the summer of 2008, it was razed to make room for a larger town hall facility.

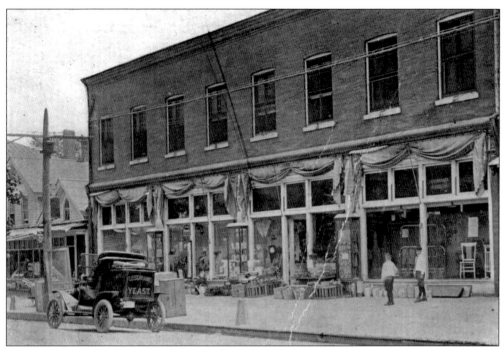

In the 1800s, Black's store was the showplace of the downtown. It was nearly a half block wide and offered shoppers everything from furniture to general home needs. Upstairs included rented apartments. Black's continuous window displays set the example for all other stores.

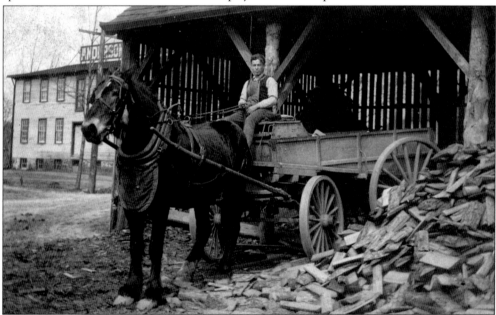

The driver of this horse and wagon pauses for the camera near an outdoor shed at Imhoff's Lumberyard at Pleasant and Second Streets around 1889. In the rear is a glimpse of the former French's Paint Factory building that changed hands several times before it later housed a local gift shop, the Cornucopian. The building fell victim to a lightning strike that necessitated its demolition on July 10, 2007.

PLEASANT MILLS ROAD CIR. 1905; HAMMONTON'S FIRST STORE, HAMMONTON, N.J.

Old Hammonton was originally situated on the north side of the White Horse Pike. It was there that businesses, churches, mills, and homes began clustering in the early days of the new settlement's founding. A woman before her time, Charlotte H. Speakman opened the first general store in that area on Pleasant Mills Road. The two-story building provided both housing and business for its proprietor and still stands today on its original foundation. Over the years, various owners carried out restorations, converting the entire space into a charming home, carriage house, and child's play cabin. Today the residence is part of the Colasurdo family grounds, and legend has it that the ivy on the property was started by a single cutting made by former owner Mamie Vaughan as a young schoolteacher on a class trip to the Lincoln Memorial in Washington, D.C.

EVANS WOOLEN MILL, PHOTO CIRCA 1900, HAMMONTON, N.J.

Never meant as a park of leisure, Hammonton Lake was originally used for only one reason: to serve Wetherbee's mill. Soon other craftsmen heard of the Hammonton Lake plan and decided to ride the wave to prosperity. Before it was even a few months old, the Hammonton Lake project started a flurry of business activity along its shores. Many entrepreneurs took advantage of whatever opportunities the water project offered. The Evans Woolen Mill was one of those businesses located on the edge of Hammonton Lake. Evans was one of four mills that manufactured standard-grade woolen fabric and found a viable market for its product. Later on, the mill was converted into a lovely, comfortable two-story home. Today William H. and Catherine Parkhurst III live in the original mill pictured here and enjoy a full view of the lake from all the home's front windows.

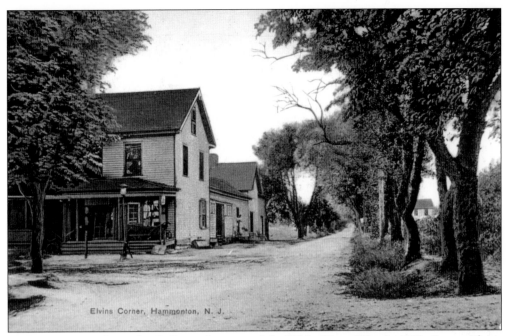

Elvins Corner, Hammonton, N. J.

Elvins Corner was located at Bellevue Avenue and the White Horse Pike. In 1862, George Elvins served as postmaster and housed the post office in his general store, which went on to be operated by several generations of the Elvins family. The second floor served as an early community hall where organizations and churches held their meetings.

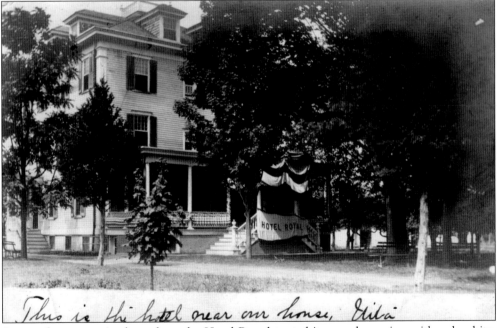

This is the hotel near our house, Iola

As was the custom in those days, the Hotel Royal touted its grand opening with red, white, and blue bunting. A temporary sign is attached to the centralized step arrangement so there would be no mistaking it for any other establishment. It earned itself a general reputation for its comfortable accommodations and fine food.

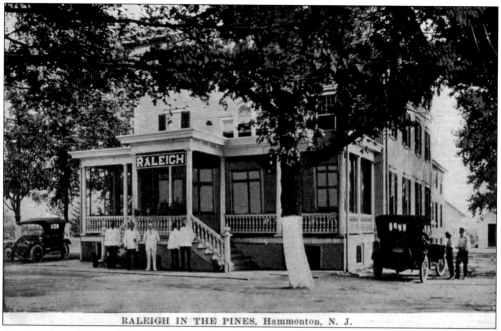

RALEIGH IN THE PINES, Hammonton, N. J.

Proving the validity of John French's resolve that alcohol was imperative to his hotel's success, the advent of Prohibition in 1919 threw the Raleigh Hotel into hard times. French held on as long as he could, but finally New Jersey state officials purchased the hotel in the 1920s. Eventually it became the headquarters for the area's New Jersey State Police Troop A.

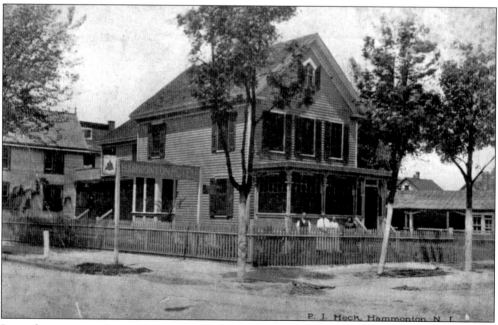

P. J. Heck, Hammonton, N. J.

Large homes were featured on postcards to demonstrate Hammonton's resolve to become a credible community with fine residential neighborhoods. Some even used a portion of their homes as boardinghouses. Here Heck family members proudly pose in front of their home turned Hammonton Hotel.

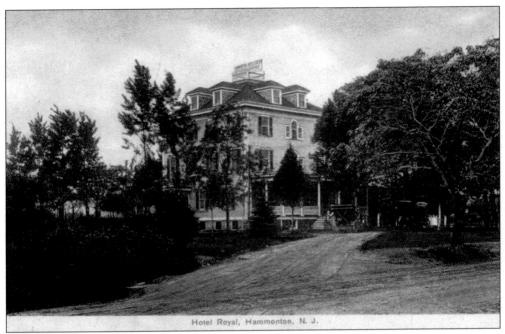

Hotel Royal, Hammonton, N. J.

There is little written about the Hotel Royal. It is known that it was located approximately a quarter of a mile from the Hammonton Lake Park. Tourists traveled to Hammonton in the late 1800s and early 1900s to touch and drink the healing waters of the lake. The Hotel Royal was situated to accommodate those visitors.

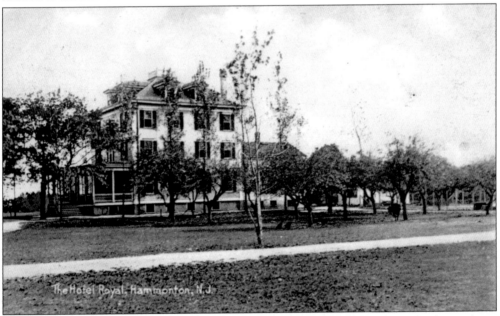

The Hotel Royal, Hammonton, N. J.

While the Hotel Royal as seen above was quietly carrying on business, the Raleigh Hotel was in the horizon in the same neighborhood webbed in controversy. Shrewd owner John French fought and won a bitter battle with the town council, insisting he must serve alcohol to his thirsty bicyclist guests. His establishment was highly rated in the 1890s and fast became a popular rendezvous for Hammonton's elite.

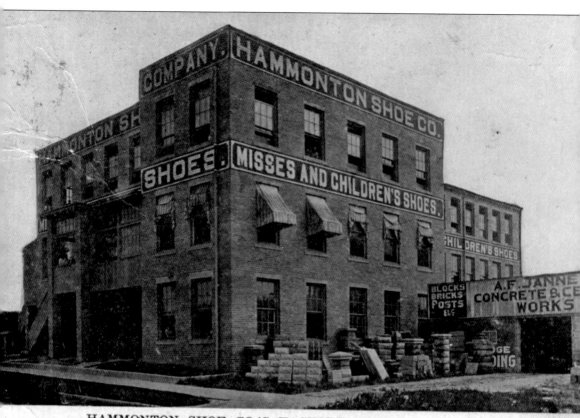

HAMMONTON SHOE CO.'S FACTORY, Hammonton, N. J.

In the late 1800s, Hammonton became the home of many factories, including clothing, shoe, glass, paint, and more. After Hammonton was incorporated and moved its downtown to its present location, many businesses followed while new ones were founded. Capt. C. J. Fay's Hammonton Shoe Company employed over 100 residents, specializing in shoes for women and children. Driven by a true entrepreneurial spirit, Fay sought to expand his operation beyond the walls of his factory. With that goal in mind, he commissioned young Italian girls to crochet baby booties at home. The results of their labor were sold right along with the children's footwear. Notice A. F. Jannet's Concrete and Cement Works is to the right of the shoe factory and obviously in the very early stages of his business. Many fine buildings were later credited to the Jannet enterprises, including his own family's home at Bellevue Avenue and Packard Street, which is still standing today.

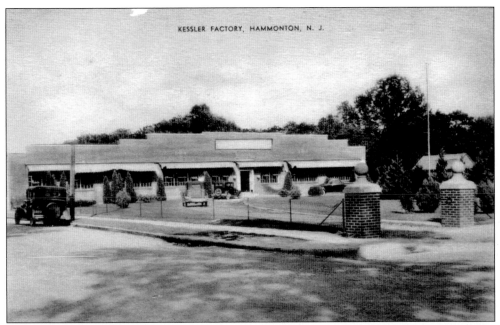

In the 1920s, William B. Kessler founded his men's clothing factory. With outlets in New York, Chicago, and Los Angeles, his workforce grew from just 25 to over 500 employees by 1945. Kessler kept his workers on the job throughout the Great Depression and was held in the highest esteem by all who knew him.

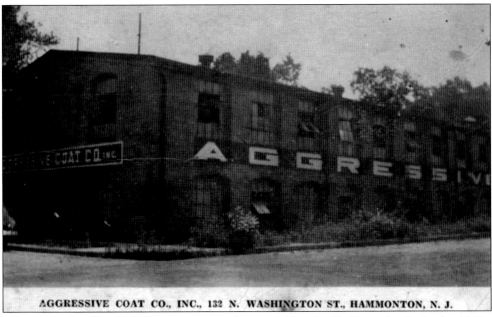

AGGRESSIVE COAT CO., INC., 132 N. WASHINGTON ST., HAMMONTON, N. J.

The Aggressive Coat Company, owned and operated by the Hoffman family in the 1940s, offered a local shopping outlet. Entire families shopped there since the Hoffmans manufactured garments for children, men, and women. Its success motivated the Hoffmans to later build an addition to house the outlet operation.

19

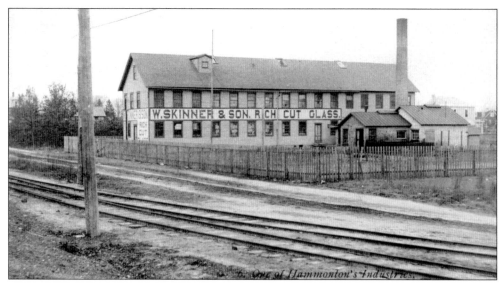

W. Skinner and Son was credited as a premier cut-glass factory. Its pieces are highly collectible today. Family members were so dedicated to their facility that when the last survivor, Thomas Skinner, died in 2006, the machinery inside the factory was still in perfect working order even though its doors had been closed for decades.

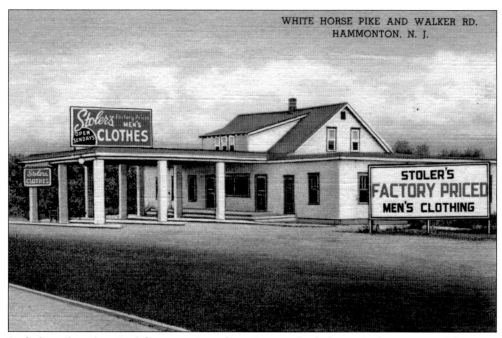

Stoler's outlet advertised factory prices, featuring men's clothing. Its home-turned-business architecture was characteristic of the 1920s and 1930s, as was offering a two-lane carport for the shopper's convenience. Signage was plentiful, rounding out the showroom's colorful presence.

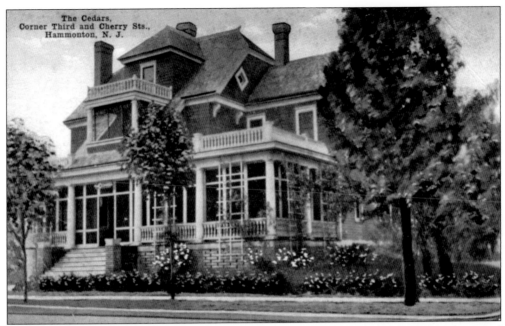

The Cedars was a grand home, quartering servants on the third floor. Its magnificently carved staircase served as the focal point of the front receiving hall. In the late 1950s, it became a multifamily apartment-style home.

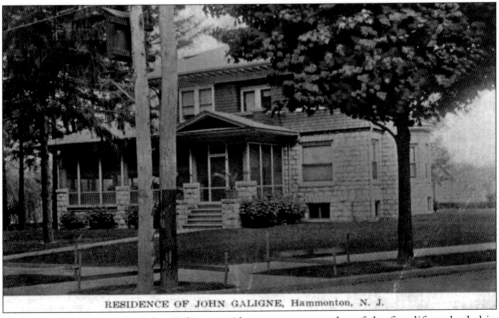

Such grand homes as the John Galigne residence were examples of the fine life to be led in Hammonton during its early days. They indicated that ambitious and industrious residents were able to amass fortunes. Galigne was proprietor of a shoe factory in 1904 and was later involved with the local sewer plant in 1913.

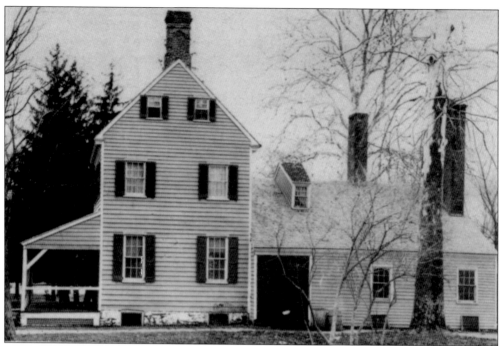

In 1812, William Coffin operated a sawmill and later a glass factory. His residence on the lakeshore was conveniently situated near his flourishing glass works made up of the factory, workers' homes, and buildings necessary to make up a settlement. Today Kessler Memorial Hospital sits at that location.

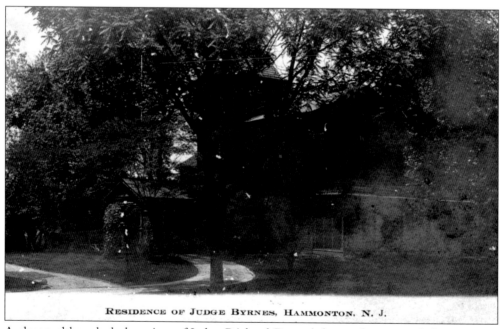

RESIDENCE OF JUDGE BYRNES, HAMMONTON. N. J.

A closer, although darker view of Judge Richard Byrnes's home shows a path for carriages and automobiles leading to a carport of sorts for shelter where drivers assisted in boarding or dispatching passengers. He maintained landscaping worthy of the finest mansions.

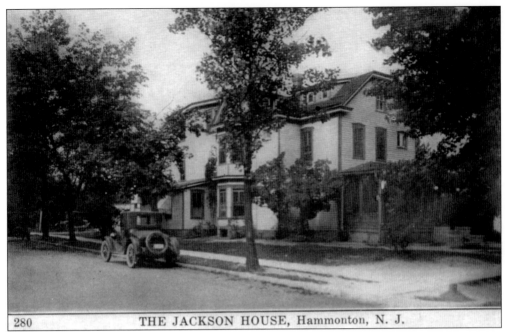

280 THE JACKSON HOUSE, Hammonton, N. J.

The Jackson house held some prominence in Hammonton as the home of the town's first mayor, Marcellus Jackson. It was considered a mansion by the town folks, but the Jackson family members were well known for their generosity and civic participation and did not view their home in such a way.

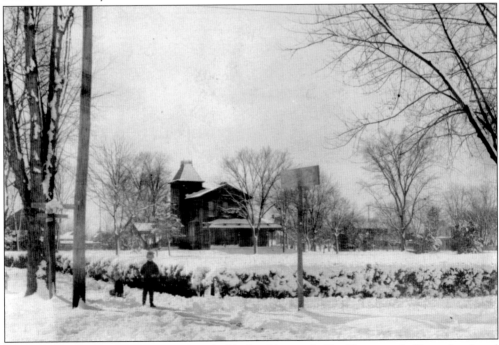

Judge Richard Byrnes's home was built in the block-wide parcel of land between the Pennsylvania and Reading Railroads. A two-story structure, it was also regarded as a mansion. Here a young boy peers at the photographer, who surely feels he is snapping a true winter wonderland photograph.

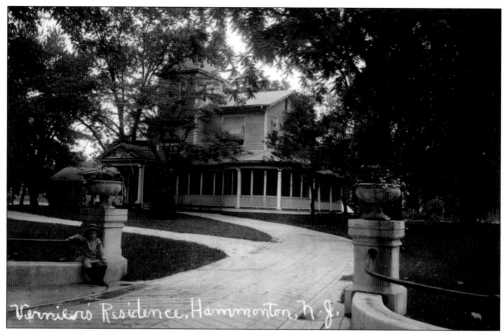

The sender of this postcard referred to this *c*. 1914 home as the Verniler residence. The roundabout porch style provided additional living space where the family gathered in the evenings whenever the weather permitted. A child sits on the left concrete entrance post. Two large jardinieres overflow with greenery.

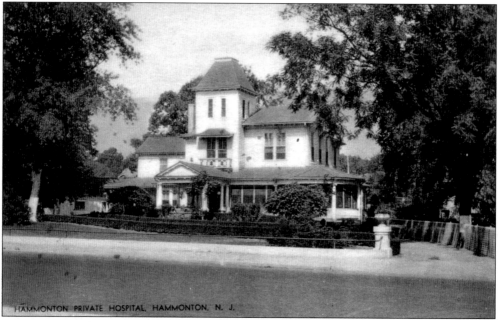

In 1920, Dr. Anthony J. Esposito purchased Judge Richard Byrnes's mansion. There he founded and operated the Hammonton Hospital. Receiving his education at the University of Pennsylvania and Hahneman Medical College, the finely trained surgeon went on to develop his hospital into a top-notch medical facility.

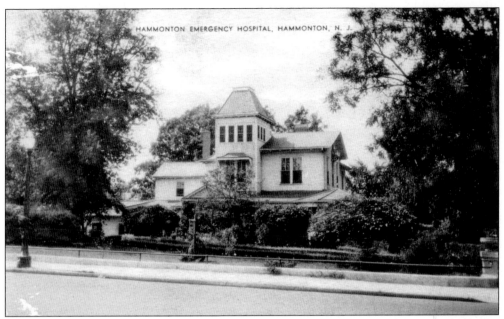

Esposito's wife, Myrtle, was a fully trained nurse who proved extremely valuable to her husband's hospital endeavor. Her love for gardening led her to add a goldfish pond to the front of the property, which drew great attention, especially from the children passing by.

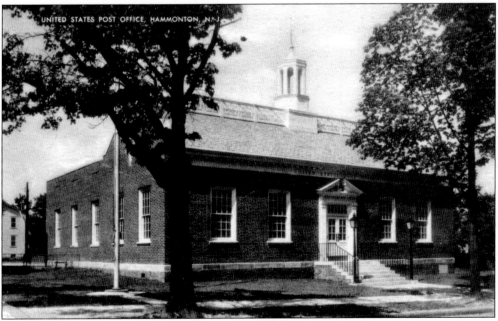

The Hammonton Post Office, erected in 1937 by an act of Congress, provided employment for local men after this country's Great Depression. Workers were hit hard during those years, working for 10¢ to 25¢ a day, if they were fortunate to find any work at all. The new post office symbolized a new era of promise and prosperity.

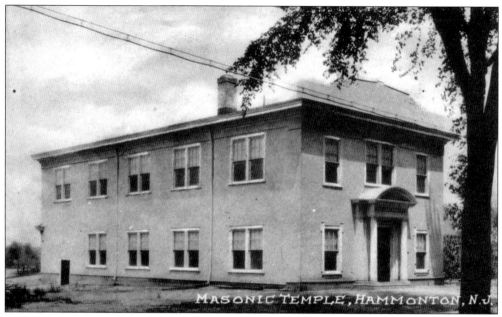

MASONIC TEMPLE, HAMMONTON, N.J.

M. B. Taylor Lodge was established on February 19, 1875, by charter members E. D. Redman, Dr. H. E. Bowles, C. P. Hill, S. Draper, I. W. Warner, C. P, Wescoat, J. H. Jones, G. W. Rich, and O. Packard. They were all members in good standing before arriving in Hammonton. By 1889, most local businessmen had been admitted into the order, meeting two Fridays a month.

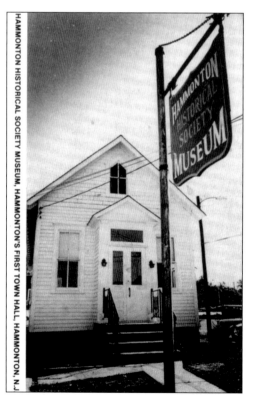

HAMMONTON HISTORICAL SOCIETY MUSEUM, HAMMONTON'S FIRST TOWN HALL, HAMMONTON, N.J.

This building was Hammonton's original town hall. In the 1940s, it became the town library; in the 1960s, a kindergarten classroom; and finally in the 1970s, the Historical Society of Hammonton Museum. In 2006, it was moved two blocks down Vine Street to the Lions International Club's Leo Park. It received a total refurbishing and is still home to the Historical Society of Hammonton Museum.

Two

A PLACE TO STROLL

This 1909 view of Bellevue Avenue was a culmination of the founders' dream. Their pitch to prospective buyers was drenched in promises of wide, tree-lined roads where wagons could comfortably pass each other with parked wagons along the sides.

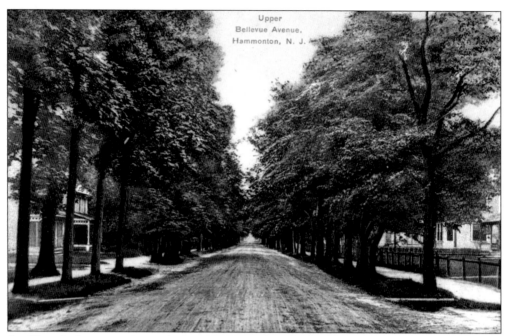

Seedlings became grand trees lining the sidewalks of Bellevue Avenue and pointing the way downtown. Even though a residential neighborhood was established, and the trees are well on their way to being fully grown, the sidewalks and roadways are still not yet paved. This setting is an example of the town's devotion to maintaining meticulously manicured streets.

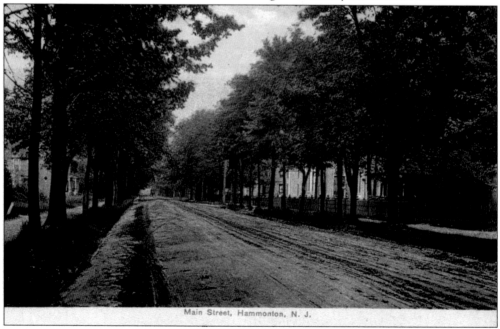

Adhering to the tree-lined street marketing plan, the precursor of sidewalks are seen here as simple dirt paths, which came into being by natural progression. From the time of its conception, Hammonton has paid charming tribute to the typical stereotype of an American small-town streetscape.

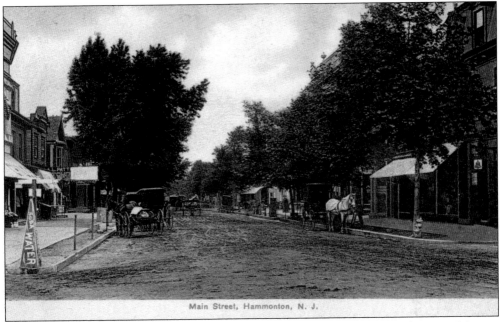

Main Street, Hammonton, N. J.

Hammonton's main street, Bellevue Avenue, was typically quaint during its horse-and-buggy days. A pyramid sign advertises water and sodas. An interesting observation worth mentioning is the presence of the hitching posts all along the curb for the townspeople's convenience, much like parking meters would look today.

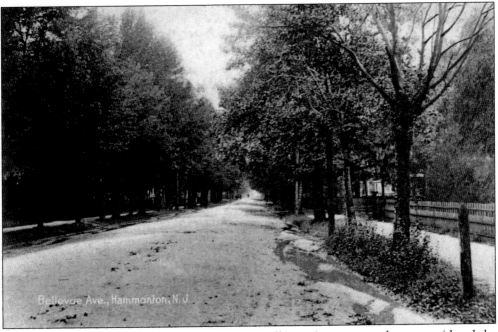

Bellevue Ave., Hammonton, N. J.

Although a dirt thoroughfare in its early days, Bellevue Avenue was always considered the gateway to the town. Trees provided a lush streetscape, shading the grand homes on both sides of the avenue. A lone hitching post stands in the foreground. Ornamental wooden fencing has made its way into the rural town of Hammonton.

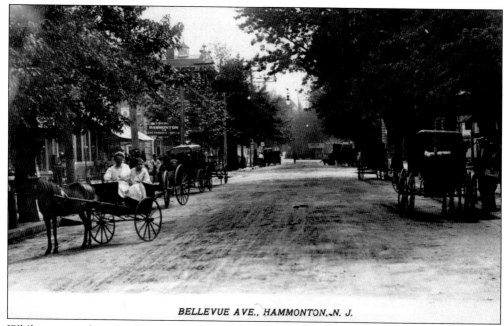

BELLEVUE AVE., HAMMONTON, N. J.

While many cards were published of Bellevue Avenue, this scene is the most charming. Horse-drawn carriages are lined up for as far as the eye can see, carrying shoppers or deliveries to businesses. The town's viability is apparent, suggesting life in Hammonton was enjoyable and just a tad cosmopolitan, thus underscoring the small town with a big-city persona.

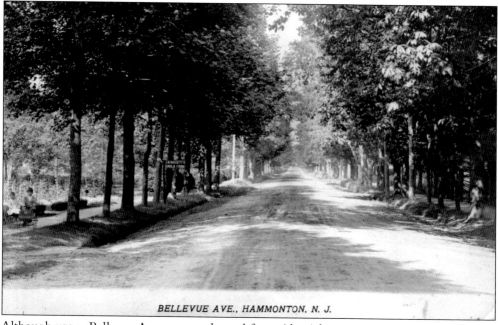

BELLEVUE AVE., HAMMONTON, N. J.

Although upper Bellevue Avenue was planned for residential use, in 1889, William F. Bassett surrounded his home with acres of ground dedicated to his nursery business. He was credited with introducing the strawberry plant to local farmers. He noted in his 1889 advertisement that he had a dedicated love for his business and a good botanical education.

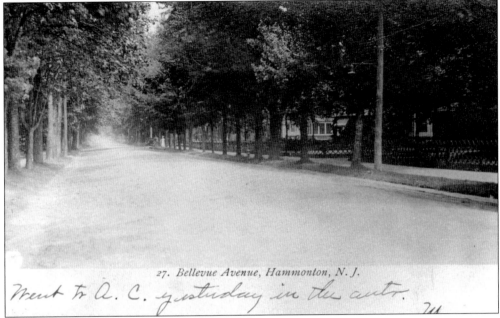

27. Bellevue Avenue, Hammonton, N.J.

Went to A. C. yesterday in the auto.

Opened to the public in 1858, Bellevue Avenue was quickly completed so its branch streets could be opened shortly thereafter. Town planners believed that established streets attracted new residents at a faster pace than uncharted sections. It has always been a heavily traveled roadway, even today.

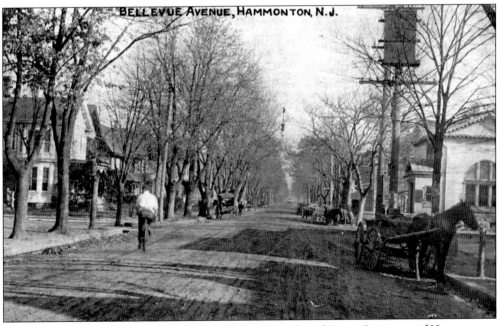

A horse and wagon wait by the side of the People's Bank and Trust Company of Hammonton while another resident favors his bicycle as his choice of transportation. Residences already lining downtown Bellevue Avenue were later converted into businesses.

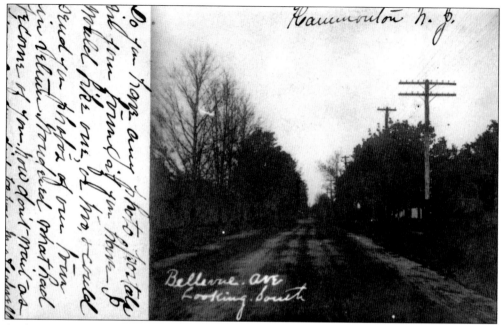

As the main street of town, Bellevue Avenue was the chosen entrance to Hammonton from its very beginning. Totally tree lined, its width heralded visitors' arrival to its downtown flanked by the large homes built along its parameters. It served its task well.

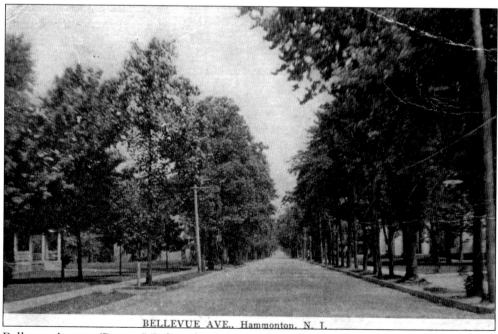

BELLEVUE AVE., Hammonton, N. J.

Bellevue Avenue (Route 54) directly connects the White Horse Pike to the Atlantic City Expressway. For many northern states and communities, it is the closest route to their destinations on the south side of Hammonton, thus bringing much tourist travel right through the center of town.

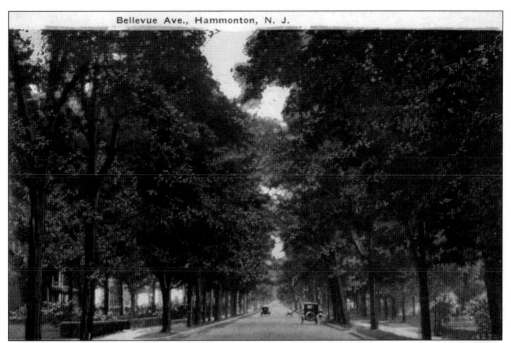

At one time, the double lineup of trees, one on the residents' properties and the other along the street, gave the Bellevue Avenue postcard photographs a faux three-dimensional effect. The early-1900s automobiles add a bit of whimsy to this scene while serving to document the time line of the photograph.

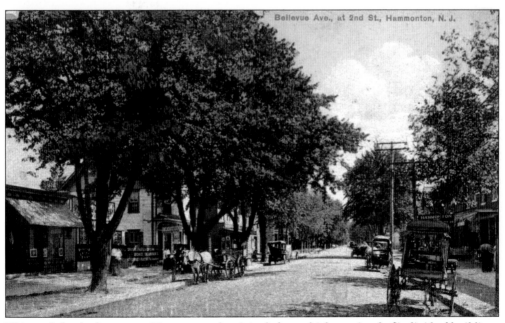

This card clearly documents Hammonton's original plan, which consisted of individual buildings lined up side by side to form the downtown. Trees provided beauty and shade while serving to mark off a pedestrian path out of the way of the automobiles and horse-drawn wagons.

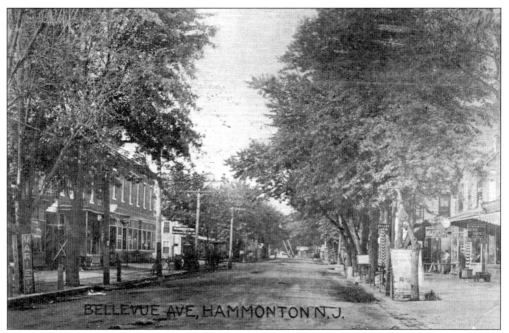

BELLEVUE AVE. HAMMONTON N.J.

Postmarked February 12, 1912, and sent to Milwaukee, Wisconsin, this card personifies the idyllic life on Bellevue Avenue at that time. To the right is a small sign attached to the building under the clock that reads, "Hammonton News Agency." Electric poles, complete with glass insulators, are plentiful. Again, trees soften the streetscape, offering welcome shade to the pedestrians.

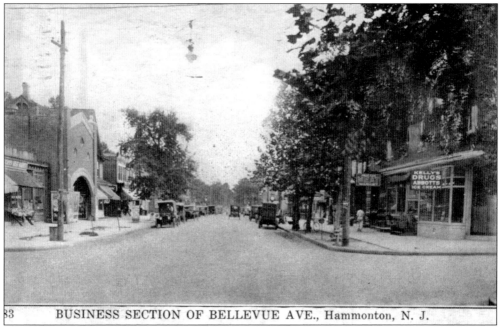

BUSINESS SECTION OF BELLEVUE AVE., Hammonton, N. J.

This exceptional postcard of the center of Hammonton's downtown reveals the Palace Theater on the left, a modern movie theater of the early 1920s situated in the center of the town. Kelly's Drugs, on the right, is where moviegoers gathered after the shows for refreshing Abbott's ice-cream sundaes.

34

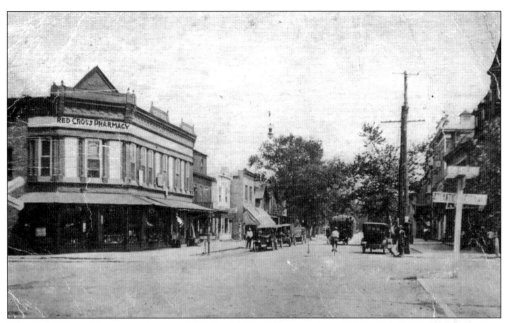

The Red Cross Pharmacy is prominently depicted here as the south gateway to the downtown of Hammonton's business district. Directly across the street is a sign that bears the name of the intersection, today known as Egg Harbor Road and Bellevue Avenue.

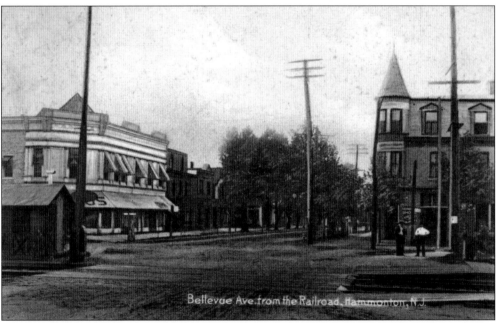

Bellevue Ave. from the Railroad, Hammonton, N.J.

The Pennsylvania Railroad tracks defined the south end of Hammonton's downtown. Further definition was provided by the two most ornate downtown buildings seen on this corner, which together dwarf the small enclosure on the left. Its purpose was to shelter the railroad gatekeeper who manually raised and lowered the signal gates whenever a train approached or left the station.

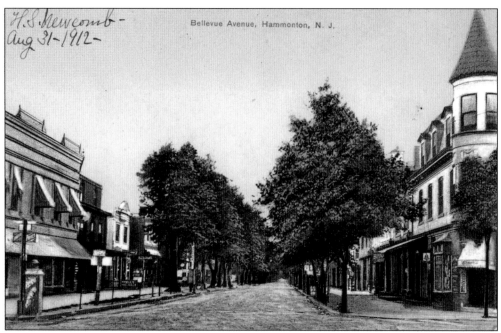

H. S. Newcomb —
Aug 31 – 1912 —

Bellevue Avenue, Hammonton, N. J.

H. S. Newcomb sent this card with a 1¢ stamp to her sister on August 31, 1912. Curiously, she chose a pristine scene of Hammonton's downtown without activity to send a joyful, moving message. Today this 100 block of Bellevue Avenue is much the same, with the exception of the corner building on the right that succumbed to a devastating fire.

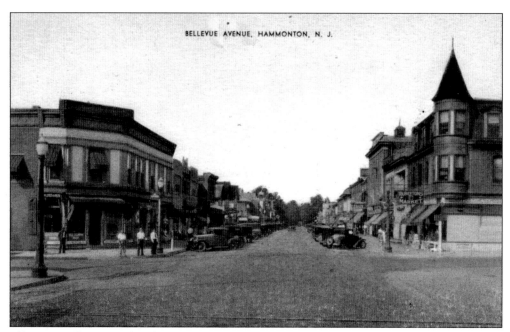

BELLEVUE AVENUE, HAMMONTON, N. J.

Elliot J. Woolley, a watchmaker and jeweler, was credited with building the first three-story brick building in the Hammonton business district in 1888, known as Woolley's block. He housed his business in one of his stores, rented the rest, and lived in another section with his wife.

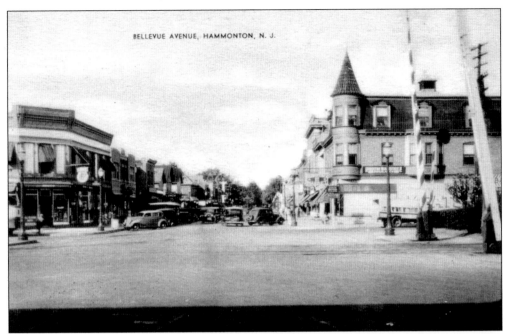

BELLEVUE AVENUE, HAMMONTON, N. J.

This popular view of Hammonton's downtown is enhanced in this postcard. It offers an entire overview of the shopping district from the railroad tracks that are laid perpendicular to the downtown. This 1930s photograph illustrates a vibrant business section bustling with activity. Angle parking gave way to the parallel curbside style in the 1940s.

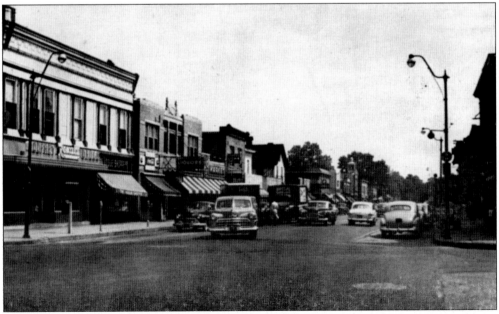

A similar view of Hammonton's downtown in the late 1940s illustrates the same buildings surviving the passage of time while the horse and wagons have given way to automobiles. The street is, of course, paved and bustling with motorists. Parking meters have indeed been installed along with attractive streetlights.

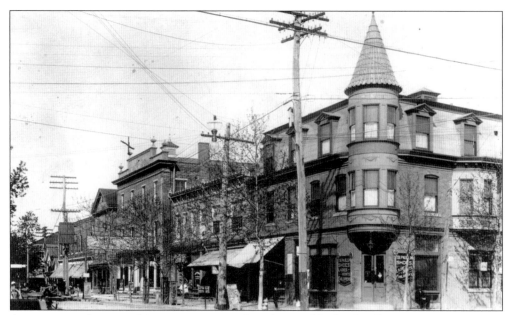

A panorama of great architecture is captured in the 100 block of Bellevue Avenue's business district. "T. B Paullin Shoes, Ladies, Gents, Children's" is identified on two signs attached to the corner building. Individual structures of earlier years were later connected to form one long, continuous parade of storefronts, instituting a progressive, modern trend that remains today.

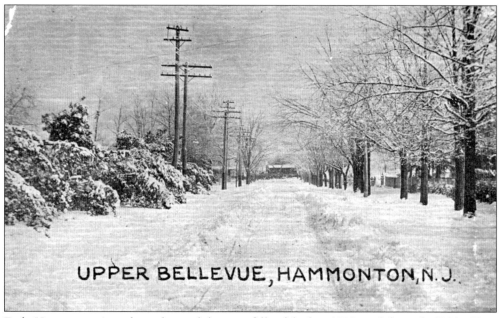

UPPER BELLEVUE, HAMMONTON, N.J.

Early Hammontonians always boasted the snowfalls of the late 1800s and the early 1900s. Here a photographer braved the cold to document one of those heavy storms. A full blanket of snow coats power lines, tree branches, roadways, and roofs.

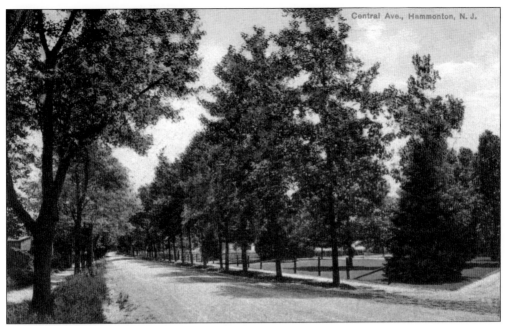

Tree-lined streets were the dream of Richard Byrnes and Charles Landis, cofounders of Hammonton. Central Avenue was generously gifted with an abundance of hardy shade trees, which provided pedestrians as well as horse-and-carriage passengers welcome cover from the summer sun.

Central Avenue, Hammonton, N. J.

As the years passed, foliage was cleared along the Central Avenue roadside to make way for private residential development. That section of town went on to host the largest and most prestigious homes of all the residential neighborhoods.

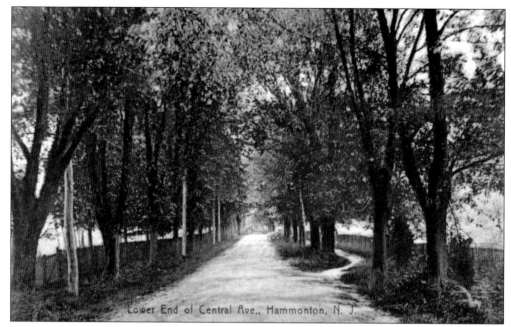

Lower End of Central Ave,, Hammonton, N. J.

While many townspeople rode horse and wagons, horse-drawn carriages, and later horseless buggies, there were scores of pedestrians and cyclists on the town's streets. Here a footpath was forged inside the line of trees by foot travelers' constant traffic, as they watched out for their own safety.

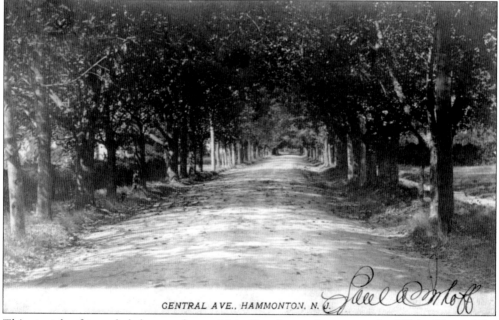

CENTRAL AVE., HAMMONTON, N. J.

This stretch of trees led the traveler to Main Road, now known as the White Horse Pike (Route 30). Sometime in the 1900s, artist George Washington Nicholson, who later received national recognition, maintained a residence and studio in this section. His longtime friend and artist of national acclaim John Singer Sargent spent much time here and is said to have painted Nicholson's portrait.

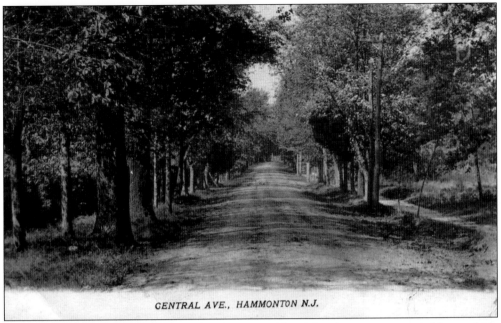

CENTRAL AVE., HAMMONTON N.J.

The early Central Avenue harbored the choicest residential real estate surrounded by roadside trees and greenery. Such photographs were publicized to attract new residents in search of the idyllic small-town lifestyle. That marketing campaign was hailed as "extremely successful."

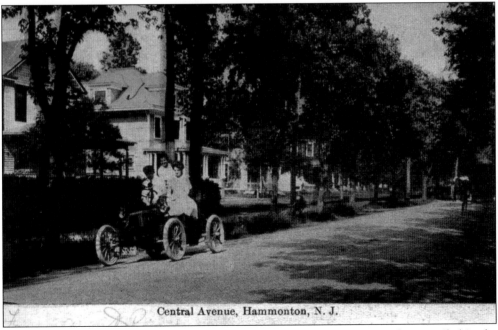

Central Avenue, Hammonton, N. J.

Long ago, an unidentified former Historical Society of Hammonton member penciled in the identification of James and Mary Cottrell, seen here sitting in their automobile as they leave for an afternoon drive along Central Avenue. They are wearing their motoring outfits. This card was sent by E. W. White to Vermont, wishing Della Hill a happy 16th birthday in 1909.

41

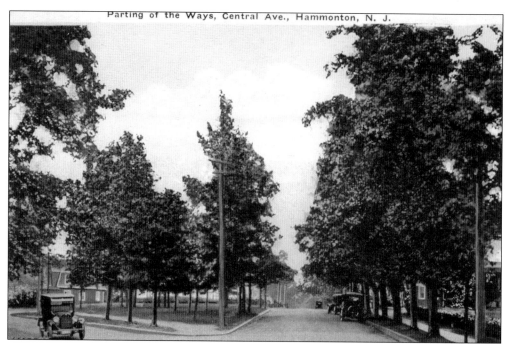

Establishing a green triangle at Third Street and Central Avenue was an insightful gesture by town planners, who reserved green space for public pleasure at a time when land was plentiful. It has remained intact to the present day. Flanked by St. Mark's Episcopal Church, St. Joseph High School, and the post office, it is still the hub of weekday activity.

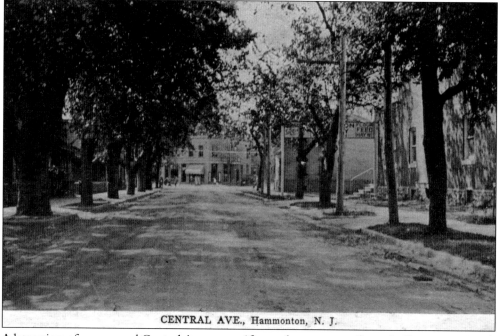

A later view of an unpaved Central Avenue testifies to the presence of trees indigenous to South Jersey, leading to Hammonton's downtown. The downtown developed as quickly, if not sooner, as the outlying residential, business, and agricultural areas.

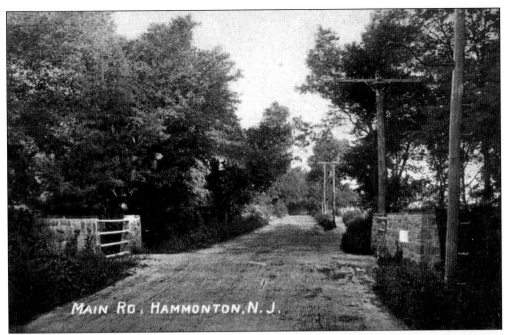

MAIN RD, HAMMONTON, N. J.

Main Road provided a bicycle path as well as a carriage and automobile passage. The bridge provided safe crossing over a naturally existing stream. It was said that this spot was a stopping place for young lovers who enjoyed gazing down at the moving water.

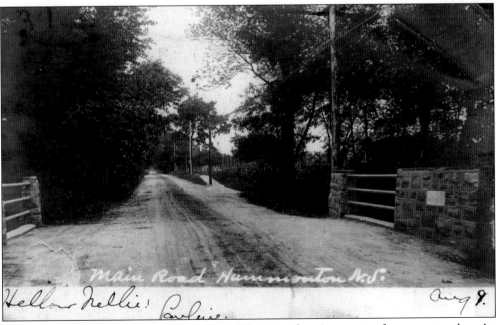

This charming bridge along the White Horse Pike was a favorite rest stop for weary travelers. An early postcard provided no space for greetings on its reverse side. It was reserved for the address only, so senders scripted brief messages on the card fronts. This one is simply dated August 9 in the hand of the writer.

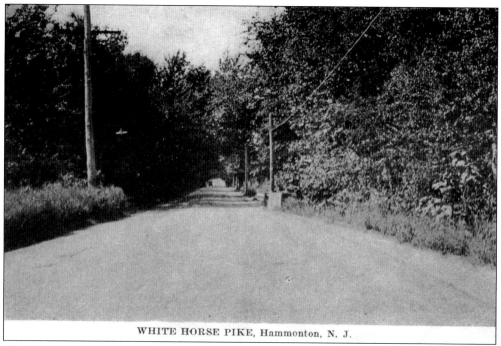

WHITE HORSE PIKE, Hammonton, N. J.

Although Main Road is identified here as the White Horse Pike, this is a very early view, most probably before it received the White Horse Pike recognition. It shows the narrow road and thick forest that had yet to be disturbed to make way for later modern-day heavy traffic and business construction.

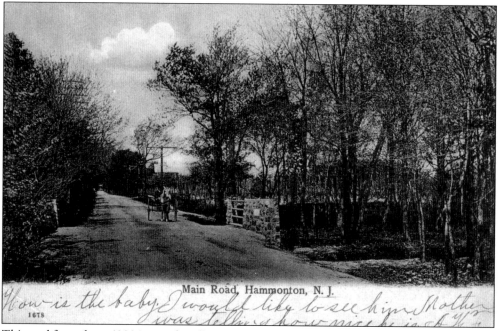

Main Road, Hammonton, N. J.

This card from about 1900 is a perfect illustration of life in Hammonton at that time. A lifestyle is frozen in time by this one photograph. So many postcards look like carbon copies of each other, but it is possible to find unique background details that may serve as historical research clues.

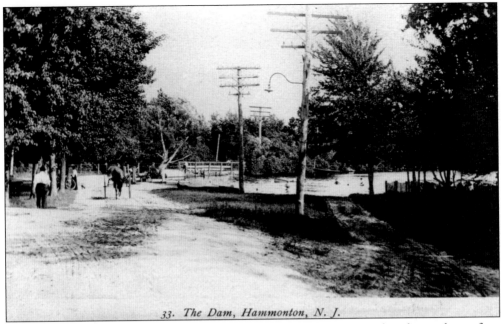

33. The Dam, Hammonton, N. J.

A horse and wagon pass by the dam while bathers enjoy the water. Others have taken refuge in the shade. The natural setting along Route 30 (White Horse Pike) has long given way to progress, but the atmosphere still remains.

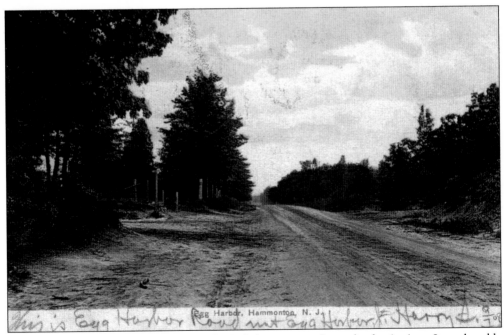

Egg Harbor, Hammonton, N. J.

This original entrance to Hammonton Lake Park demonstrates its modest beginnings. It was humbly situated on the well-traveled Egg Harbor Road, and it led to an incredibly well-known attraction: the healing waters of Hammonton Lake deep in the beautiful Pine Belt forest. Even a seasoned traveler not familiar with the territory could very well pass right by this healing destination.

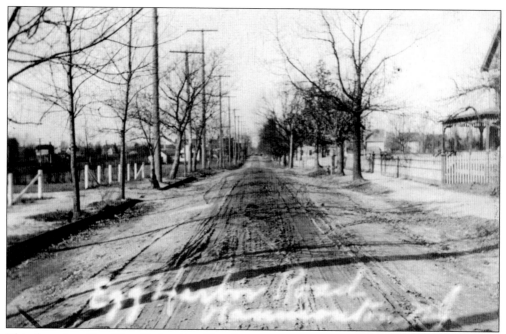

This charming side of Egg Harbor Road is a classic vintage view of Hammonton. Homes far apart, dirt roads, and wire fencing all denote practical design for necessity not for ornamental show. Since it connects the White Horse Pike to Hammonton's downtown and housed the Raleigh Hotel, Hotel Royal, and Hammonton Lake, it saw many daily travelers along its way.

Trees offering welcome cover from the summer sun line the way along Egg Harbor Road, passing right by the hotel district. As was the custom, tree trunks have been treated to ward off insects collecting around escaping sap trickling down the bark. Large homes have been built along the way, allowing motorists a scenic trip to and from the shore.

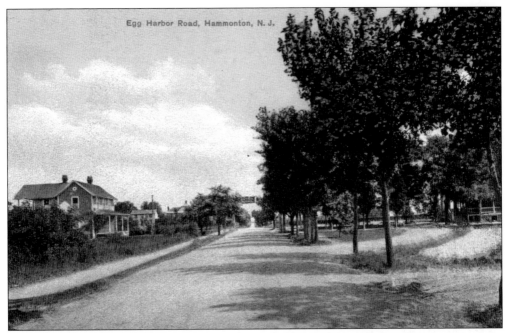

In a short time after the town of Hammonton was chartered, Egg Harbor Road attracted the construction of large residences even though it was unofficially earmarked as a thoroughfare for business development. Many entrepreneurs lived on the same grounds of their business establishments. Most of those original homes are still in fine condition today.

This postcard depicts the beginnings of Third Street in Hammonton. During this time, Maple Street was the preferred street of travel between Central Avenue and Egg Harbor Road. It was not until later that Third Street was inhabited as a residential neighborhood.

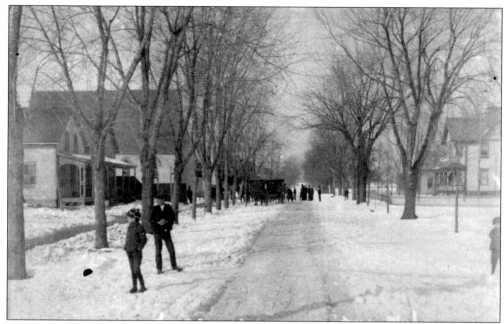

North Third Street attracted those residents who did not want a downtown lifestyle but still looked to be close to neighbors. Still maintaining neighborhood status, many homes were built on acreage rather than lots, some even housing farms. Frankie Avalon's grandmother Concetta DeLaurentis lived on both sides of Third Street during her lifetime, where the singing icon often visited her.

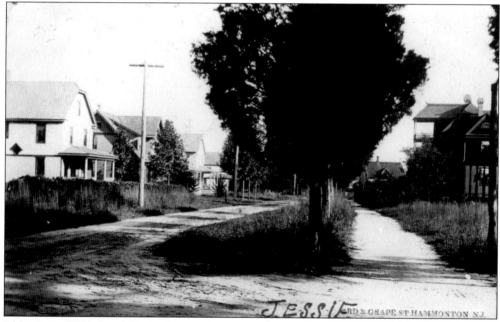

This view of Third and Grape Streets gives a visual grasp of the times. A wide strip of roadway is set aside for the horse and buggies, while a more narrow path has been beaten by pedestrian and bicycle traffic. The residential cluster and electric pole indicate progress and modernization on the move. This card was posted from Sicklerville in 1905.

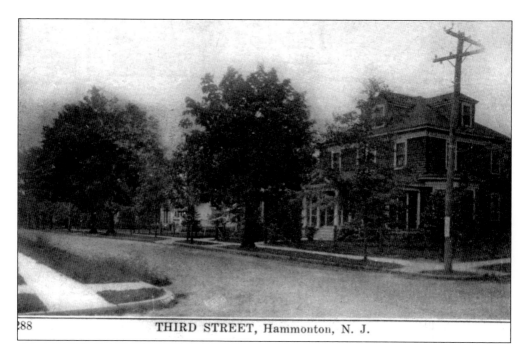

THIRD STREET, Hammonton, N. J.

Third Street enjoys an adventurous span dissecting Central Avenue, crossing the downtown and continuing all the way to the White Horse Pike. Except for a few blocks encompassing St. Joseph Church, school, and convent, the Lady of Mount Carmel Carnival Grounds, the Sons of Italy lodge, and interspersed businesses, it has retained its cordial residential complexion.

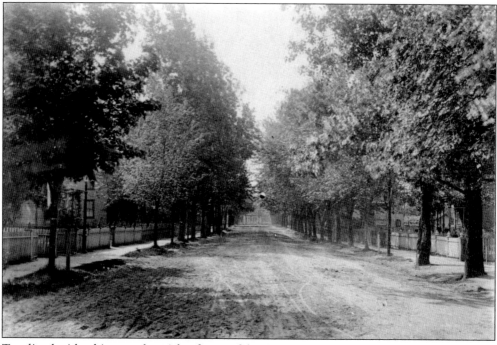

Tree lined with white wooden picket fences of the times, Horton Street was a typical downtown Hammonton residential neighborhood where families took time to enjoy each other. Veering off the main street, the condition of the dirt road indicates an abundance of street activity.

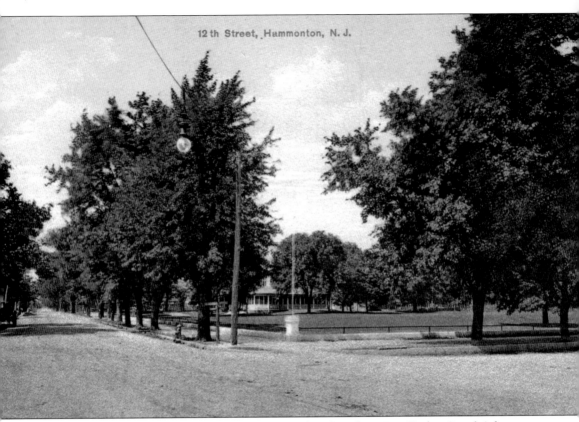

12th Street, Hammonton, N. J.

After the town's main thoroughfare crosses the railroad tracks at Egg Harbor Road, it becomes Twelfth Street, an extension of Bellevue Avenue. Even though Bellevue Avenue is on the north side of the tracks and Twelfth Street is at the south, and both carry names chosen by the local people, they are commonly identified by the state as Route 54. This seemingly unremarkable route carries a minimum of 20,000 vehicles daily, a far cry from this peaceful postcard depiction of its dirt-road days. A horse in the distance and a rustic streetlamp hanging across the way complete the picture. Nowadays, connecting the White Horse Pike to the Black Horse Pike, Atlantic City Expressway, and beyond, many travelers find the Twelfth Street connection the shortest route to their destinations. In the summer, the number of passing cars has been estimated to exceed 22,000 a day.

Three

A PLACE TO GET AWAY

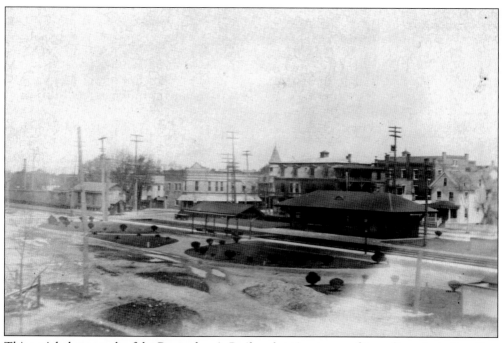

This aerial photograph of the Pennsylvania Railroad station is one of its earliest views. Standing alone amid an infant town and landscaped grounds, it presented a cordial welcome to tourists motoring in from the south approach. It also provided Hammonton with yet another sign of its credibility as an up-and-coming community. The station serviced great numbers of travelers daily.

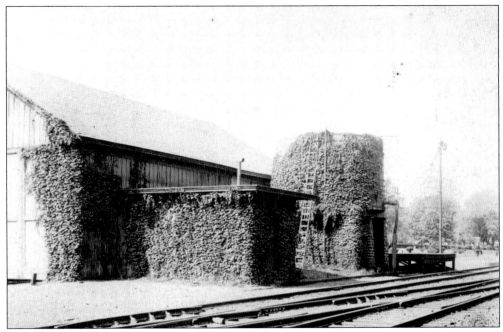

This Pennsylvania Railroad station engine house was situated across from the station house proper. The ivy sheath covering its exterior gives insight to the years of service this installation had already given to the railroad. A shelter for passengers traveling to Atlantic City replaced it in the 1920s.

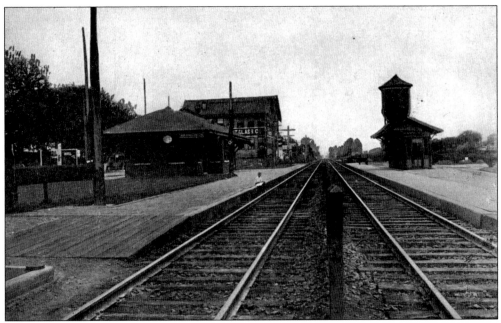

The water tower across the tracks from the Hammonton Pennsylvania Railroad station supplied water for steam locomotives. It was removed in the late 1950s when steam engines became obsolete. This view of the tracks offers an analysis of their original layout and intricacy laid by the hands of men. The separate shelter was removed in the late 1960s.

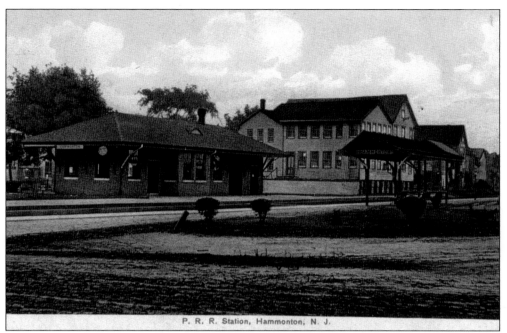

P. R. R. Station, Hammonton, N. J.

The tiny roofed alcove across the tracks sheltered passengers waiting for their trains bound for Atlantic City. The stationmaster, who sold tickets inside as well, neatly maintained the area. The town fathers harbored big plans for their community, and the advent of the railroad in 1863 cemented their agenda.

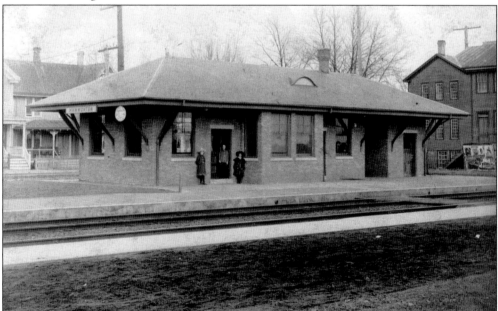

The railroad's arrival changed Hammonton considerably. Passengers were given the chance to visit the town on their way to and from Atlantic City or Philadelphia. This boosted business revenues. In turn, local residents could now visit those cities in a day trip. The Pennsylvania Railroad station offered comfort to travelers as they made travel arrangements or waited to board the trains.

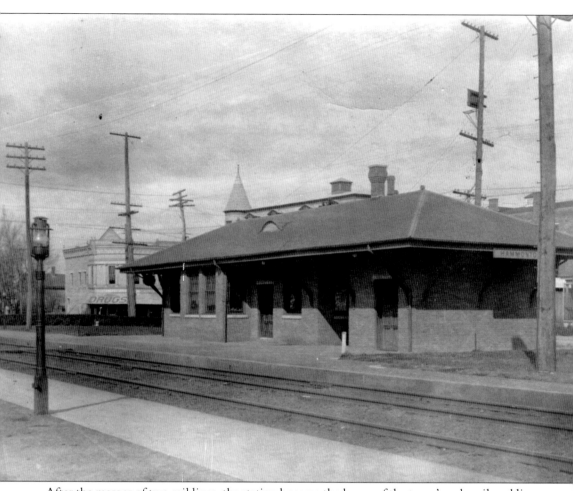

After the merger of two rail lines, the station became the home of the town's only railroad line, locally known thereafter as the Pennsylvania-Reading Railroad station. It looks very much the same today, a testament to the railroad's sturdy building techniques and its intentions to keep its service going forever. The demise of the railroad as the residents knew it came about when Atlantic City went into its pre-casino slump. With the glitter and excitement waning, passengers stopped traveling to the shore and soon freight trains followed suit, becoming nonexistent too. Two sets of tracks sat dormant for years as automobile traffic passed over them each day. Finally Amtrak successfully revised the romance of railroad travel in the 1980s. Today the train carries passengers back and forth to Atlantic City, a happy ending for a great industry.

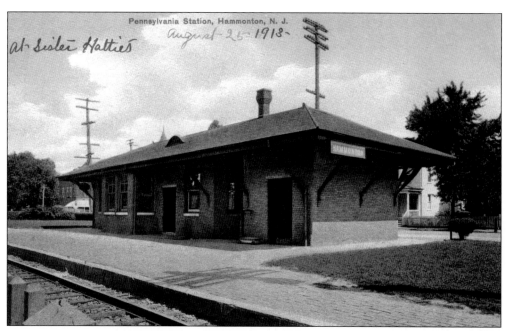

Pennsylvania Station, Hammonton, N. J.

at Sister Hattie's *august 25 1913*

The Pennsylvania Railroad station was well kept in the early 1900s, offering necessary amenities to travelers. After falling into disrepair, it was rescued and restored in the late 1990s to again become the hub of activity as a division of the Hammonton Chamber of Commerce.

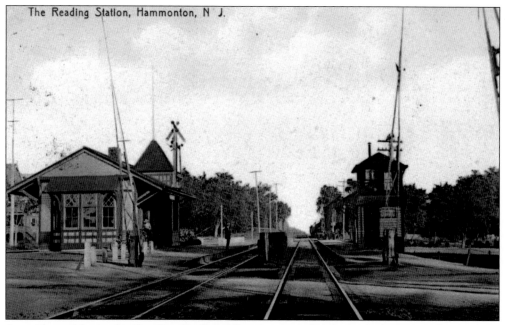

The Reading Station, Hammonton, N J.

As evidenced here, the Reading Railroad lines presented quite a nicely arranged composite picture. Gates in the air ready to swing into service, an enclosed shelter across the tracks for those passengers traveling to Atlantic City, and a finely designed station house offered an exciting haven to travelers.

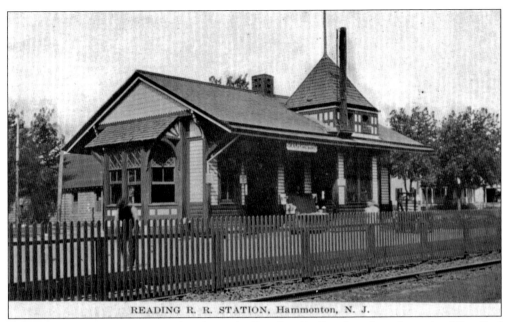

REEADING R. R. STATION, Hammonton, N. J.

This fence served as a protective barrier at the Reading Railroad station, situated at West End Avenue and Twelfth Street where the current *Hammonton News* building now stands. The fastest-running trains in the world traveled these tracks on the Camden-to-Atlantic City run, most reaching speeds of 90 to 100 miles an hour.

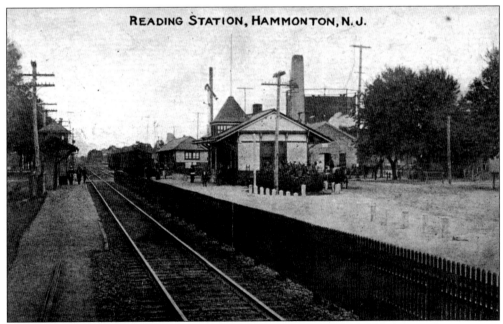

READING STATION, HAMMONTON, N. J.

Although it does not appear so in this postcard, the Reading Railroad lines also offered double tracks, as did the Pennsylvania Railroad a block away. For years, there was enough traffic to keep the two local lines prosperous, but when circumstances changed, the two companies merged in 1933. These tracks were abandoned at that time.

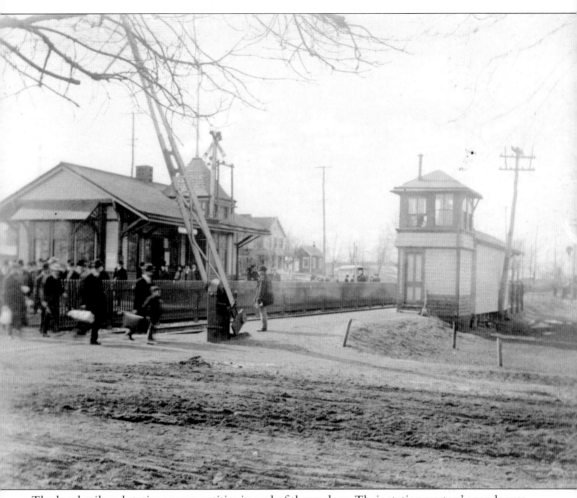

The local railroad stations were entities in and of themselves. Their stationmasters' agenda was specific: to serve passengers and keep them informed of the train's arrival and departure times. However, their jobs required much more. They needed to keep order among passengers anxious to make their trains, restless children, rattled parents, and slow-moving people with no pressing, personal timetables. They were expected to supervise all the day-to-day operations pertaining to their respective stations. In addition, they needed to be at their windows selling tickets and taking care of business. Here passengers leave the Reading Railroad station to wait in the south side passenger shelter, apparently on their way to the shore. It was well known that the Reading lines offered stations of more elaborate architecture as well as finer-designed interiors for the comfort of their travelers. The gate remains postured for service, stopping traffic for the oncoming trains.

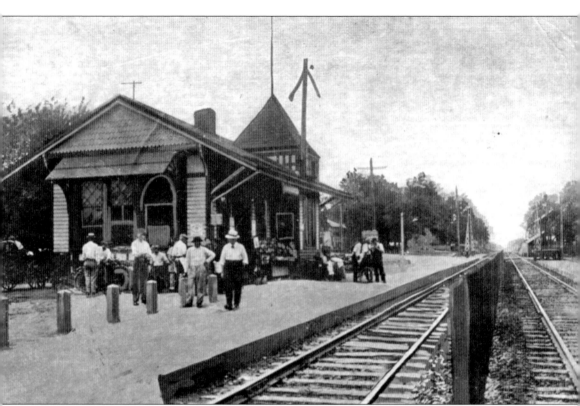

The railroads wore many hats. While passenger travel is romanticized in postcards, the lines carried on big business for industry too. For some reason, not many postcards are devoted to the freight trains of the day, but whenever they passed through town, children of all ages stopped to watch. Certainly passenger trains were plentiful in the railroad's heyday, but freight trains of seemingly never-ending lengths passed through Hammonton on a regular basis. They went all over the country, carrying oil, lumber, steel, food, and more. Freight cars of all shapes, sizes, and colors were specifically designed for different uses, making their passage a work of modern art in motion. Lineups of motorists patiently waited as railcar after railcar rode past, while children happily named each car's purpose. Cabooses signaled the end of the train, the place where workers took breaks and grabbed hot, strong cups of coffee.

Four

A Place to Learn

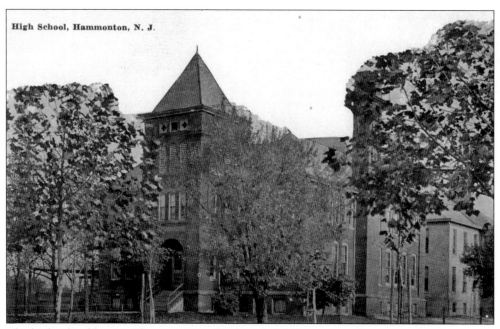

The high school became the grammar school in the 1920s. As a result, the primary school was instituted in the former grammar school building. The trees are almost fully grown, serving as a testament to the residents' knowledge and attention directed to the care of all greenery. Due to its deteriorating condition, this original building was demolished in the 1970s.

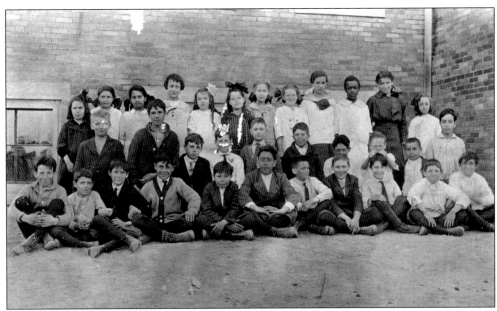

Nestled in a cozy corner of the school building, Hammonton schoolchildren happily pose for a class photograph. Taking a clue from their clothing, it was obviously a springtime ritual. Helen Imhoff wrote on the reverse side of this card, "Miss Rogers," identifying the teacher.

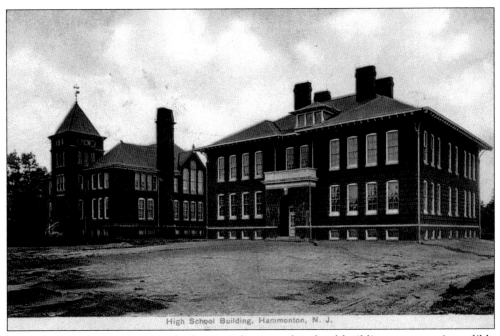

High School Building, Hammonton, N. J.

For a town made up of primarily farmers, these stately school buildings were an incredible achievement. The population was about 6,000, and yet the school buildings were designed with space to last until the 1970s, when students were placed on split sessions. The student population could no longer be accommodated by the school's old arrangement.

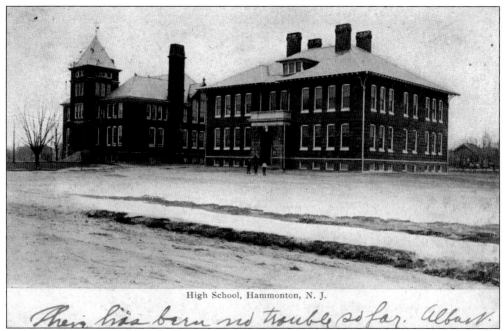

High School, Hammonton, N. J.

Their has been no trouble so far. Albert.

This card, depicting schoolchildren approaching the grammar school on foot in a dusting of newly fallen snow, carries a cryptic message: "There has been no trouble so far, [signed] Albert." It may or may not be referring to a school situation, as postcards were freely used to send messages totally unrelated to the images they portrayed.

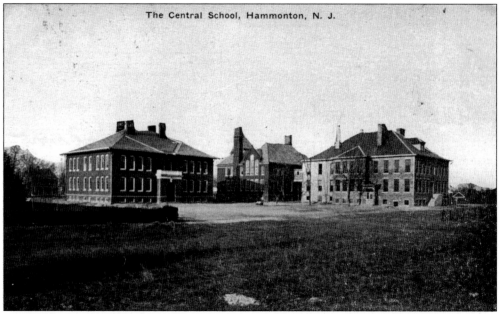

The Central School, Hammonton, N. J.

The public school buildings were sources of great pride for the early settlers. The structures indicated an establishment of an important layer of prerequisites necessary for Hammonton to be perceived as a viable community. Thus, several postcards of the same school building at various angles were published. The school postcards quickly became a vehicle to market Hammonton's progressive nature.

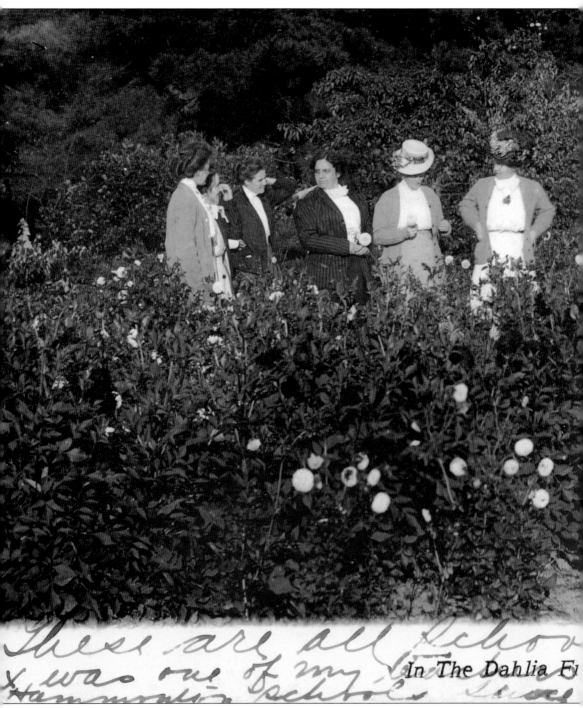

These are all schoo_ ... was one of my ... Hammonton school ...

In The Dahlia Fi...

Schoolmarms are visiting the dahlia fields of Hammonton in 1895. Understandably, they seem to be beguiled by the sea of gorgeous blooms surrounding them. One cannot help but wonder if they had any idea of the uniqueness of their day's excursion. It was expected that Hammonton's farmers would raise fruits and vegetables, but open fields of flowers for as far as the eye could see must have been a surprising and breathtaking sight for an unsuspecting passerby. Dahlias

Hammonton, N.J.

were a rare market commodity for any town, and for Hammonton to host a dahlia farm was an exceptional opportunity. Later in the early 1900s, Hammonton's leading dahlia farm owner was Cora Sooy, who, together with her children, operated a full-service florist on Ninth Street. The Sooy family also grew and processed dahlias for the national market.

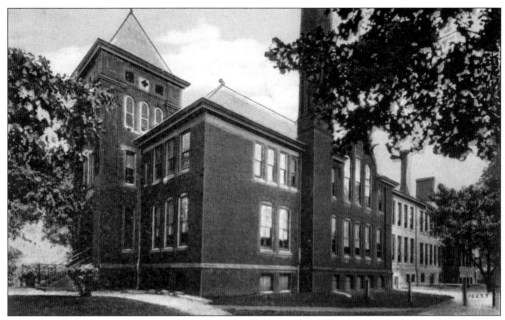

A later view of Hammonton High School is indicated by the size of the trees. Grass is now seen framed by paths serving as passive reminders to the students to stay off the grass. A suitable school yard for recess is now at one side of the building and an athletic field on the other.

It was customary to print several almost identical postcards of the same subject, as seen here. This card of Hammonton's high school was just one of a myriad published of its exterior with no attempt to add diversity to distinguish it from other similar cards. These cookie-cutter photographs were accepted by the public and avidly collected.

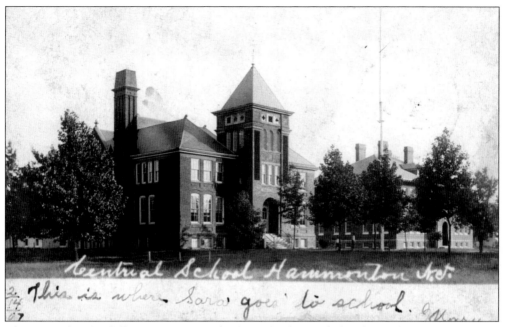

Central School Hammonton N.J.
2/14/07 This is where Sara goes to school. Mary

The personal pride of all Hammontonians for their school is verified in this card's inscription: "This is where Sara goes to school, [signed] Mary." No other tidbit is included, just a card illustrating the school grounds, carrying a message connecting the sender to the local educational system. It was definitely a prideful proclamation implying the importance of education.

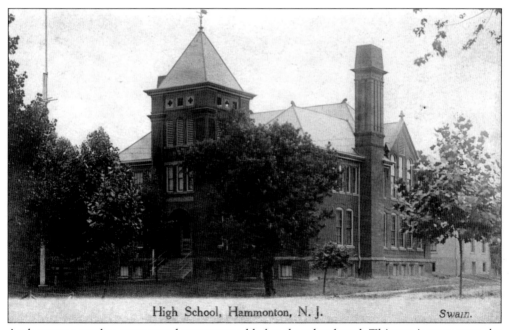

High School, Hammonton, N. J. Swain.

As the years went by, ornamental trees were added to the school yard. This was important to the townspeople, since farming was the primary occupation of the earliest settlers and later arrivals, the Italian immigrants. Trees were planted to satisfy their natural instincts with a side benefit of providing shade from the noonday sun.

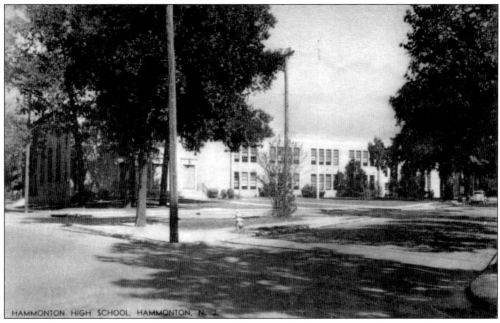

This building was constructed by the town for the Hammonton public school system in the early 1900s. In 2004, it became the home of St. Joseph High School and still retains its original charm.

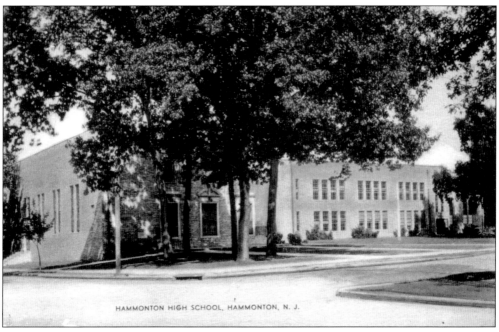

Sometime in the 1920s, a third structure was added to the school grounds. This building became the new high school, while the original high school was deemed the "new" grammar school. This view was taken well after the landscaping reached maturity.

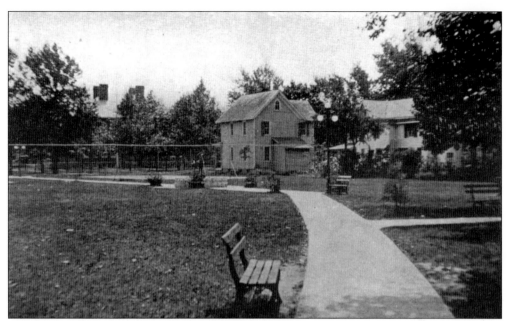

During its earliest years, School Park was plain and simple. Benches and formal walkways were provided for pedestrians, but no adornment was offered. Today the park has been renamed and is divided into Leo Park, which hosts the Historical Society of Hammonton Museum, and Veterans' Park, where impressive monuments dedicated to those who fought in the country's wars stand.

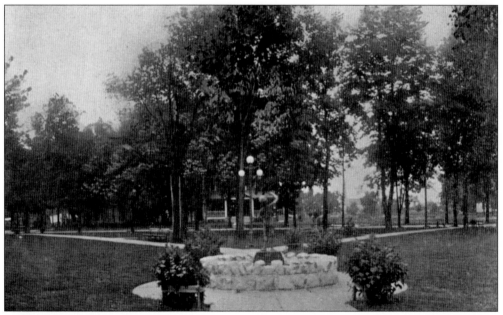

Two local ladies, Mary Tilton and Marrietta Jacobs, generously donated their respective adjoining land parcels to the Hammonton Board of Education to establish School Park. Featuring a unique, working fountain surrounded by mica schist, the park was a postcard–perfect documentation of the Victorian era. The copper bird fountain ornament was donated to the metal scrap collection during World War II.

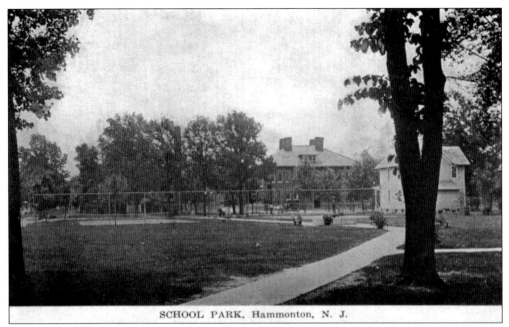

SCHOOL PARK, Hammonton, N. J.

During the ensuing years, School Park lost its original luster and ambiance. The trees and landscaping began to disappear, causing the grounds to lose their visual appeal, but it somehow went unnoticed. The message the sender wrote on this card in 1918 read, "This is a good town to spend a vacation. Our camp is six miles from nowhere."

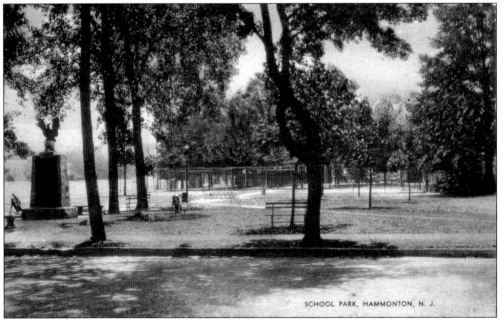

SCHOOL PARK, HAMMONTON, N. J.

Here is School Park as it appeared from across Bellevue Avenue after World War I. The monument bears the names of the local veterans who served in the armed forces during that conflict. The tennis courts were new additions surrounded by a link fence to catch errant balls in flight. In 1974, the park was transferred from the school system to the town.

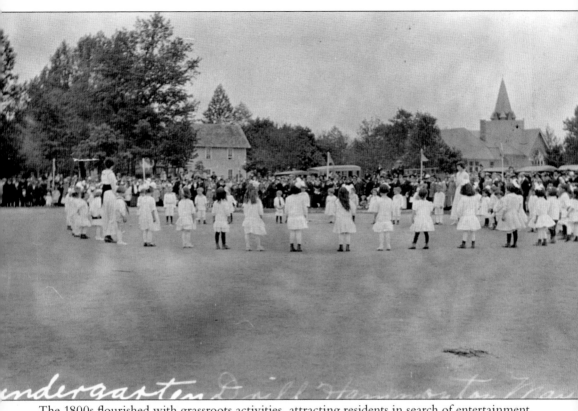

The 1800s flourished with grassroots activities, attracting residents in search of entertainment. May Day was a fine example of an event that drew a huge crowd of townspeople. Peppered throughout the spectators were moms, dads, and grandparents. There is no prouder moment for family members than watching their youngest school-age child perform with his peers. Each grade was assigned a portion of the May Day activities. All events were chosen for each grade's level of performance capability. Here kindergarten children happily form a circle as one of their presentations. Following their teacher's guidance, they danced, marched, and twirled in place before moving on to the next arrangement. While such drills seemed elementary to the older students, they indulged their younger counterparts, remembering back to when they performed that very same drill. In addition to the physical aspect, this day honed their memory, concentration, dexterity, and coordination skills as well.

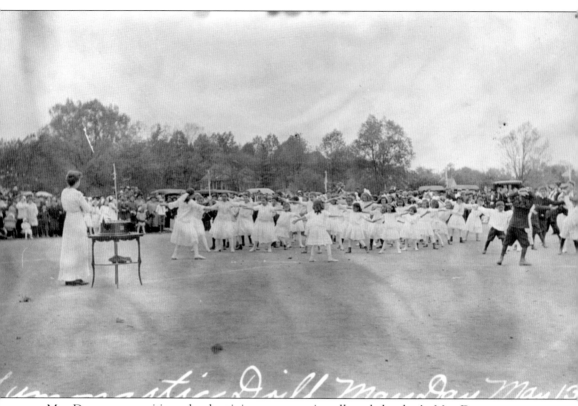

May Day was an exciting school activity encompassing all grade levels. As May Day grew near, teachers seemed as excited about the celebration as their young students. In actuality, they performed right along with their students in mind though not in body. The event was designed to entertain while demonstrating the students' physical capabilities. Here coed class members perform gymnastic moves in unison under their teacher's watchful eye. Such routines combined mental and physical concentration and took hours of practice while simultaneously teaching the youngsters teamwork, socialization, and the value of physical exercise. The last formation of each segment was usually a human pyramid, the simplest form being four crouched students as the base straddling others on their backs, with the pattern continuing until there was one student at the very top. The spectators grew more enthralled as the day progressed since the older children performed the more complex grand pyramid finale.

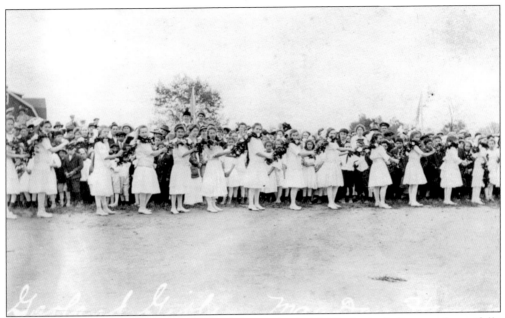

It was an envious honor to be chosen a May Day garland girl. The lucky ladies were beautifully draped in live garlands. During their number, each girl held the end of the garland of the student ahead of her and slowly and gracefully moved into different formations. This activity was surpassed only by the maypole dance of the day.

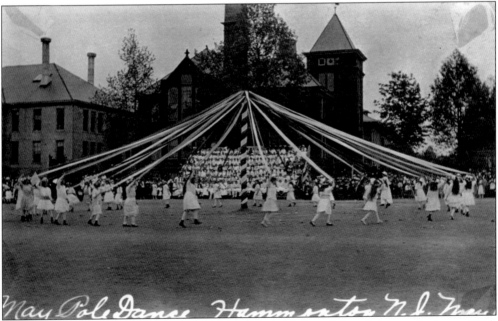

Schoolgirls diligently perform the most popular May Day activity, the maypole dance. With live music in the air, the young students mindfully hold wide ribbons attached to the top of the pole. They danced carefully while weaving in and out, wrapping the pole in a delicately patterned layer of ribbons.

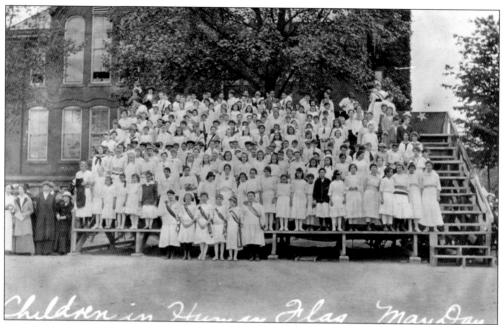

In the early 1900s, patriot demonstrations reigned high. Here a group of children are assembled and readied to hold red, white, and blue gauze banners to form the American flag. It is said the crowd sang "God Bless America" and broke into resounding applause amid deafening cheers to express its approval at the conclusion of the presentation.

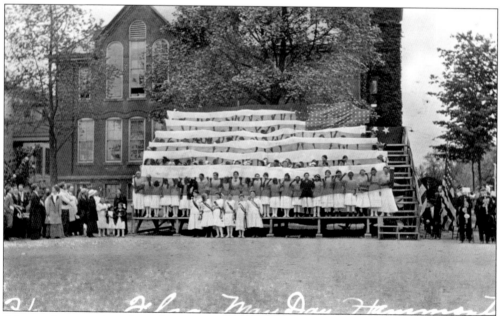

After much preparation, the students pose in human flag formation. The wooden bleachers, utilized as the basic stage, allowed each "stripe" to be clearly seen by the spectators. In the background is the original Hammonton High School, which was razed in the 1970s.

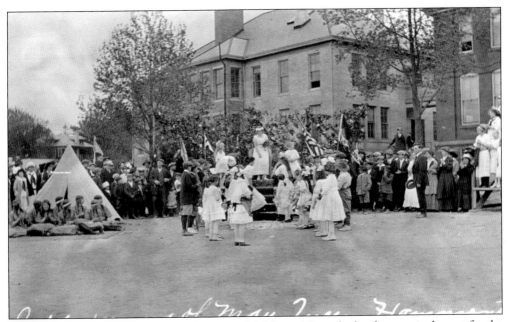

The public crowning of the May queen was a highly anticipated school-sponsored event for the entire town. Here a lucky young lady is officially crowned, flanked by her court of younger schoolgirls, all festively dressed in white. In stark contrast is Hammonton's first group of Camp Fire Girls sitting cross-legged in front of their tent wearing regulation uniforms.

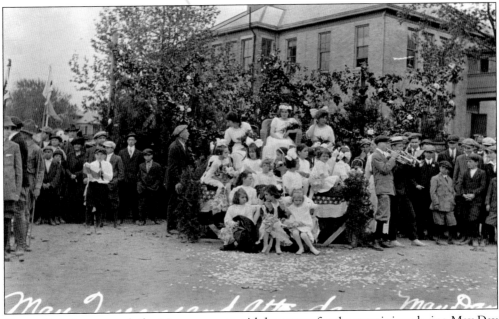

Once officially crowned, the May queen sat with her court for the remaining closing May Day exercises, bringing the day to a dramatic conclusion. Musicians, dressed in the knickers of the era, played in celebration while similarly dressed male spectators stood nearby.

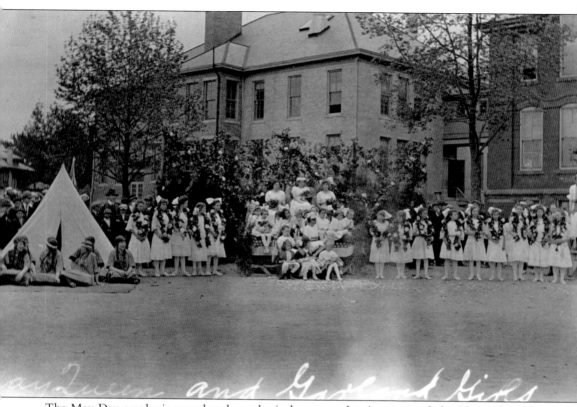

May Queen and Garland Girls

The May Day emphasis was placed on physical prowess, but it was coupled with a softer side too. The spring season naturally called for a celebration of fresh May flowers. Earlier in the day, many people, young and old, left May baskets filled with garden blooms on the doorknobs of their friends, families, and neighbors. They did not knock to catch their attention but left the discovery of the May baskets to chance, adding an additional layer of excitement to the ritual. It was a practice that sustained itself well into the 1950s. Bowing to the May flower tradition, garland girls were featured at the school's May Day exercises. They wore fresh floral garlands around their necks and had practiced long hours to finally become adept at working the garland in perfect unison during their performance. After their tedious presentation, the girls were escorted to their places of honor at both sides of the queen and her court.

Five

A PLACE TO PLAY

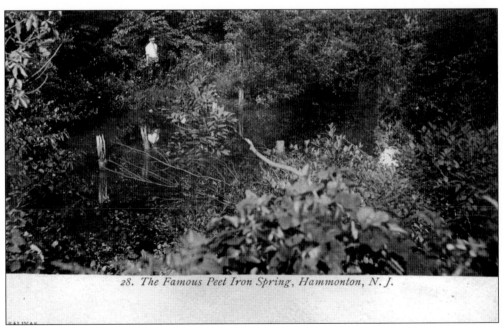

28. *The Famous Peet Iron Spring, Hammonton, N. J.*

Hammonton Lake springwater was widely believed to offer miraculous healing benefits for a variety of ailments. The iron springs in Hammonton were publicized to be as tonic as the famous springs in Schwalbach, Prussia. The condition of anemic patients was astoundingly improved by drinking and bathing in the Hammonton waters. Hammonton's air aided chromic lung afflictions, lumbago, and rheumatism.

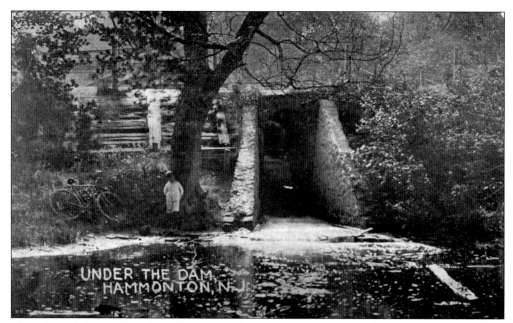

UNDER THE DAM, HAMMONTON, N.J.

The acknowledged value of the 85-acre tract known as Hammonton Lake as a major town tourist attraction motivated the town fathers to faithfully attend its needs. Its waters were drained each season. The bottom of the lake was cleaned while the dam received meticulous maintenance. This ritual drew crowds of spectators, wanting to see the dam exposed.

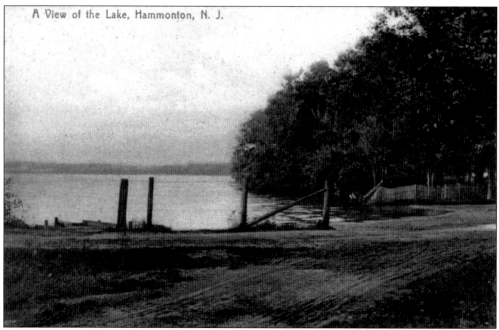

A View of the Lake, Hammonton, N. J.

This scene could be right out of a celebrated oil painting, but it is a sure bet that members of the local artist colony just down the street incorporated this view on their canvases. The fence posts become the subject of this still life, not at all unimportant to the strength of this card's subject.

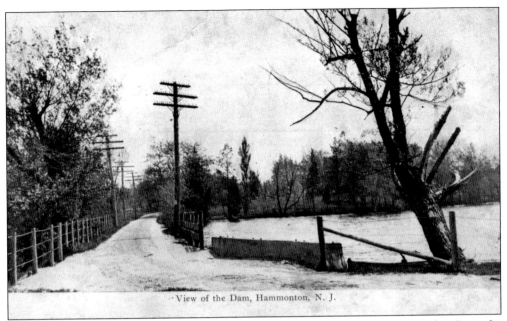

View of the Dam, Hammonton, N. J.

The White Horse Pike and dam form the northern boundary of Hammonton Lake. Once the cedar waters passed over the dam, they were redirected to pass by Coffin's Glass Mill and used as a source of power.

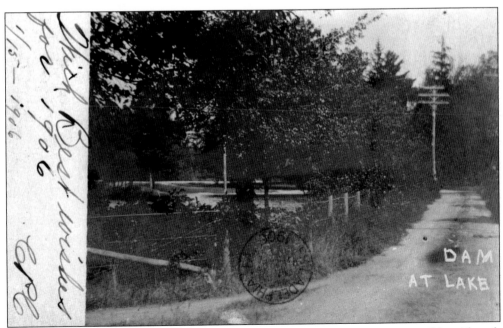

DAM AT LAKE

Postcards doubled as holiday greetings even though the images were not compatible with such seasonal messages. A sender scripted a New Year's wish on this 1906 card depicting the dam at the lake during the spring or summer months.

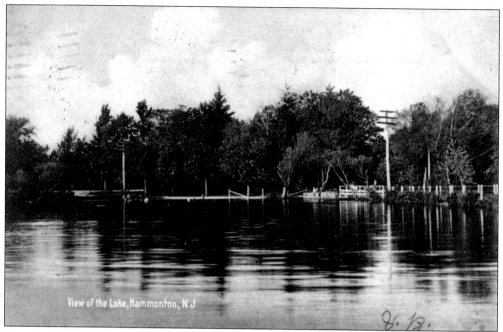

View of the Lake, Hammonton, N.J.

The long, tedious Camden-to-Atlantic City travel brought many travelers right by Hammonton Lake, tempting all to stop and take a dip. The travelers used the lake as a halfway stop on hot summer days. Many wore their bathing suits under their clothes. After a dip and a picnic lunch, they continued happily on their way.

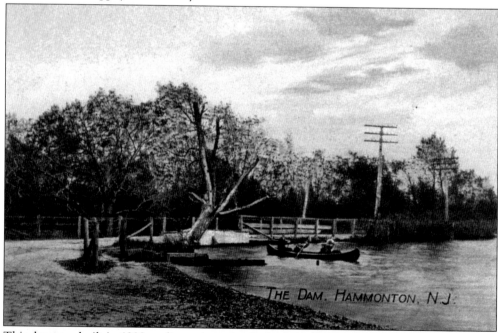

THE DAM. HAMMONTON, N.J.

This dam was built in 1808 to direct the watershed originally streaming toward the Little Egg Harbor River back to Hammonton's lowlands. This flooded the low area, amply providing the necessary water to power Wetherbee's Saw Mill situated on the banks of the lake. Soon other industries began popping up at the water's edge.

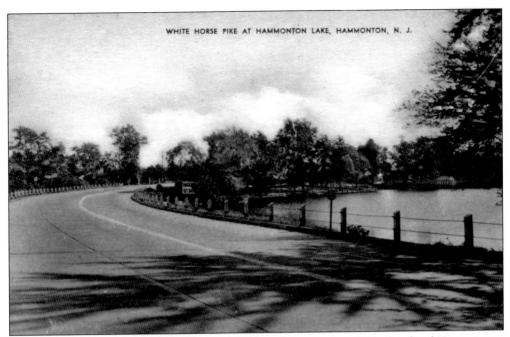

WHITE HORSE PIKE AT HAMMONTON LAKE, HAMMONTON, N. J.

A later view of the south White Horse Pike bend in the road exemplifies the placid Hammonton Lake much as it still looks today. The surrounding area was developed as the years passed, but the shoreline has been retained and maintained.

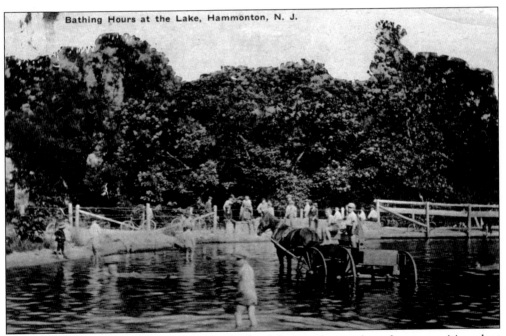

Bathing Hours at the Lake, Hammonton, N. J.

Bathing in the lake was taken literally by the local farmworkers and nearby ammunition plant employees. Recreation was not on their agendas. Even horses were allowed to step in and cool down a bit. Since the dam was in farm country, it was visited each day for this purpose.

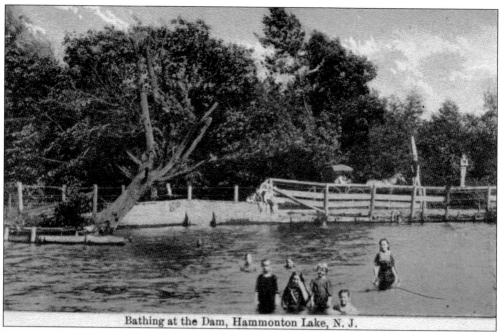

Bathing at the Dam, Hammonton Lake, N. J.

Entering the water at the dam was at the swimmer's own risk. No lifeguards were provided, but it was still frequented by those who felt confident in their water skills. Bicyclists peddled right past on their way to the Atlantic City shore and used the dam as a rest stop, often jumping in the water for a much-needed cooling off.

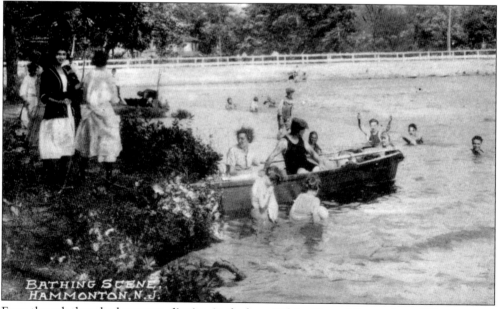

BATHING SCENE, HAMMONTON, N.J.

Even though these bathers were dipping in the busy White Horse Pike section of Hammonton Lake, it was still a serene experience. Onlookers seem to be mothers watching over their young, and one is sitting in a moored rowboat. A gentleman sits with her wearing a bathing suit, possibly serving as a makeshift lifeguard.

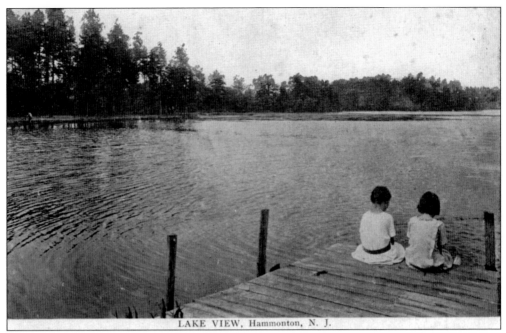

LAKE VIEW, Hammonton, N. J.

The back cover postcard was chosen for its enchanting view of Hammonton life. Here two little girls sit by the water having a very private conversation. The peacefulness of the lake's surroundings often invited such quiet bosom buddy chats.

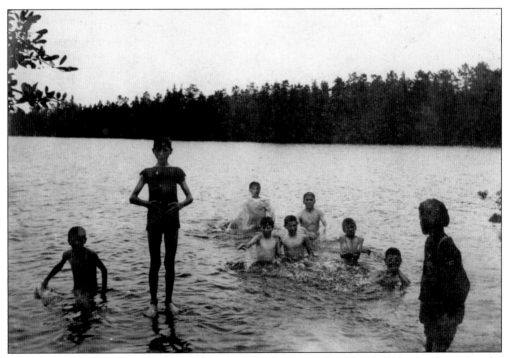

The lake was a place that everyone enjoyed. This young man is taking full pleasure in giving the illusion that he is standing on water. With no technology such as television or computer games to keep these children indoors, group activities at the lake were daily treats.

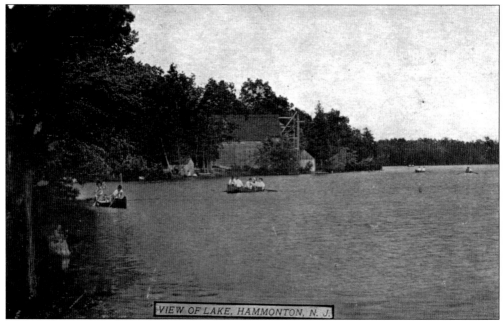

This card, bearing the handwritten message "I am having a fine time, From Hazel," sent a greeting and note of contentment in 1912. Canoeing in Hammonton was already a thriving sport, one that families enjoyed. It was the most frequently featured subject for postcards that depicted the lake grounds in the late 1800s.

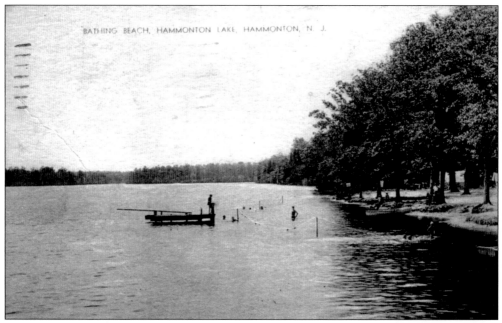

Sometimes the message on the back of a card that featured a restful scene, such as these swimmers wading in the lake, bore no reference to the picture. "Peaches are done now," this sender noted. "Paul is going to Shiebe Park to see the A's play. The township sends all boys between 9 and 15." It is a good example of Hammonton's penchant for family values.

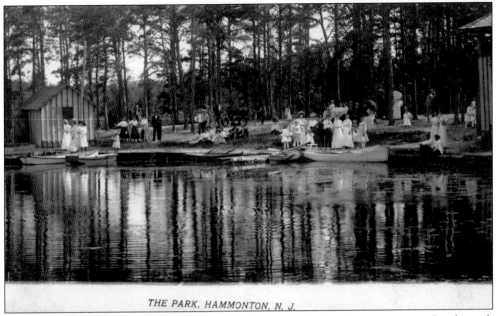

THE PARK, HAMMONTON, N. J.

The lake inspired white Sunday dresses. A hub for society during the summer months, the park offered relaxation and socialization. The residents found many uses for the grounds. For instance, Sunday school classes were held in the cabin pictured here. These adults may be waiting for class to dismiss, thus explaining the formal attire.

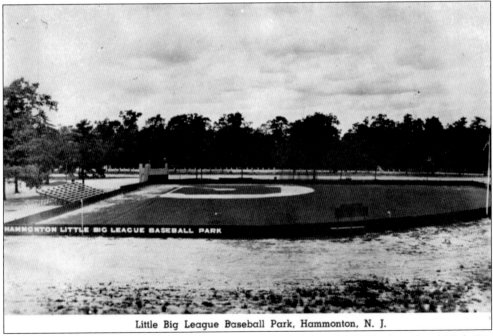

Little Big League Baseball Park, Hammonton, N. J.

Although baseball was played as a pastime, it was not until the mid-1900s that a local Little Big League baseball organization was instituted. Its fields were located within the park where they exist today. The 1949 Hammonton All Stars team went on to win the world championship at Williamsport, Pennsylvania, beating out a Florida club.

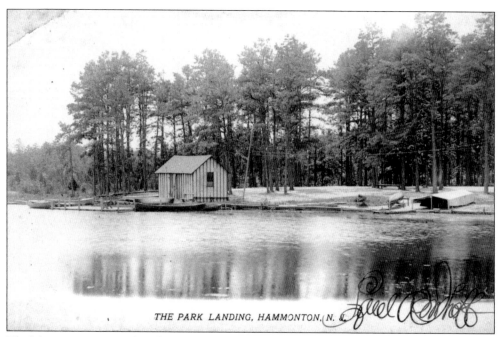

THE PARK LANDING, HAMMONTON, N.

The lake was a meeting place for Hammontonians; it was an open-air community center enjoyed by all ages. While the cabin may appear to be a utility shed on the lakeshore, this card's inscription suggests otherwise. "This is where I go to Sunday school," the sender wrote, rendering proof that the religious community found practical uses for the park grounds.

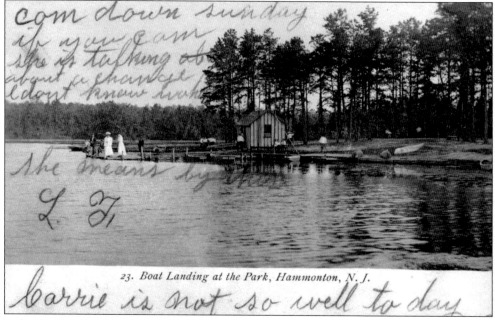

com down sunday
if you can
she is talking of
about a shawl I
I don't know what

she means by that

L F,

23. *Boat Landing at the Park, Hammonton, N. J.*

carrie is not so well to day

Ladies in their Sunday whites, clear lake water, a community cabin, men on the shore, and tree groves reaching for the sky are forever placed in the background by this message scrawled over its imagery. More than likely, these ladies were hoping for a spur-of-the-moment invitation for a boating excursion.

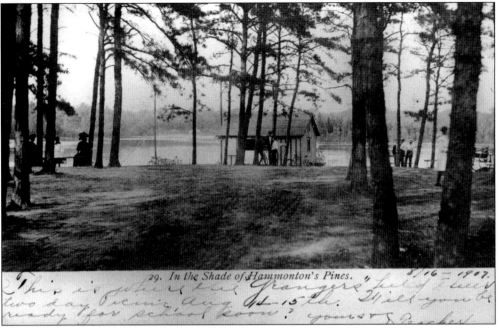

29. In the Shade of Hammonton's Pines. 8/16 - 1907.

This is where the "Grangers" held their two day picnic Aug 14-15th. Will you be ready for school soon? yours ? Parker

Even though the general belief was that pine trees drew heat rather than reflected it, this card refers to the shade of the pines. Town officials capitalized on their majestic presence as a tourist attraction. Being a friendly town in the heart of the Pine Barrens gave Hammonton an early-on marketing niche.

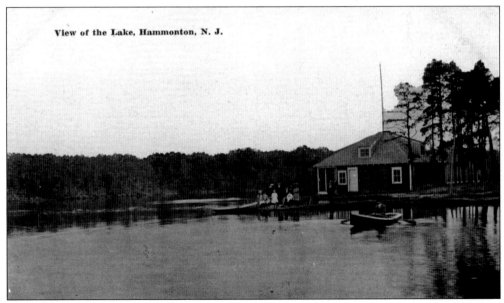

View of the Lake, Hammonton, N. J.

A gentleman in a rowboat makes his way back to the boathouse to pick up passengers who are patiently waiting at the shore for an afternoon excursion.

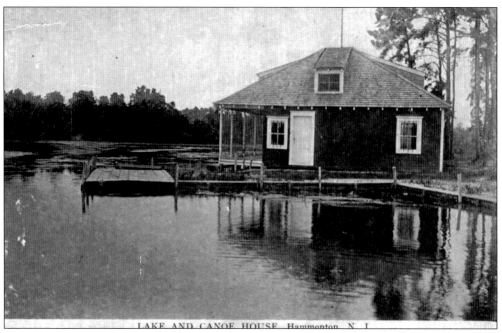

LAKE AND CANOE HOUSE, Hammonton, N. J.

Canoe houses were centers not only for the launching and docking of canoes but also for storage. Some structures were built to enable the rower to drift directly into the shelter of the canoe house without even getting out of the boat.

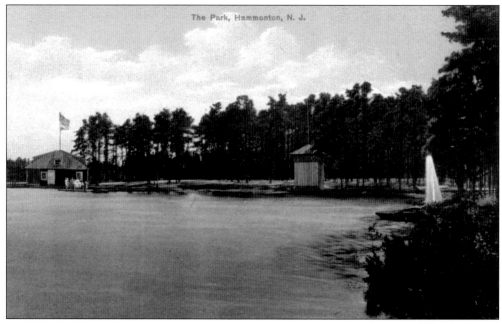

The Park, Hammonton, N. J.

The Hammonton Lake Park was an attraction not only for boaters but also for ballplayers, artists, hikers, nature enthusiasts, swimmers, and the like. Over the years, many residents and visitors have graced the shores of the Hammonton Lake Park side to engage in these activities.

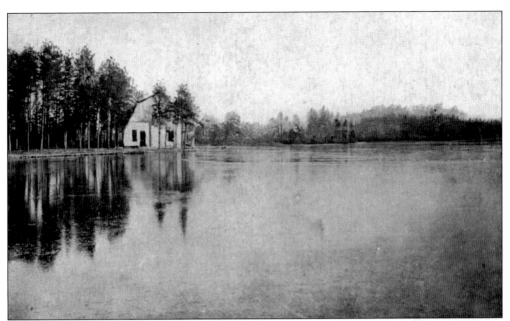

In the 1960s, Vincent DeLaurentis (an uncle of singing star Frankie Avalon) and his family lived in the spacious groundskeeper's quarters. An avid athlete and physical education teacher, DeLaurentis spearheaded various lake activities, including a summer day camp with almost all the counselors being certified Hammonton school system teachers. He also watched over a permanent refreshment stand on the grounds.

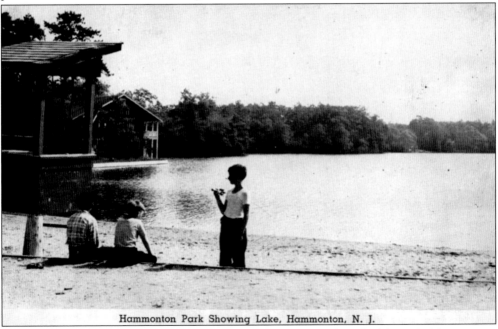

Hammonton Park Showing Lake, Hammonton, N. J.

In the 1940s, kids gathered at the lifeguard's station, sensing a bit of celebrity in his presence. During the summers of 1945 and 1946, however, the lake closed due to a polio epidemic when parents were advised to keep their kids from crowds for fear of contracting the disease. Soon after, it reopened but never to its former glory.

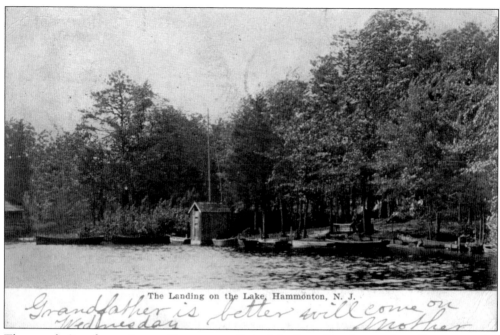

The Landing on the Lake, Hammonton, N. J.

Grandfather is better will come on Wednesday Mother

The popularity of canoeing on Hammonton Lake is indicated by the number of canoes on the landing. Nestled under the shelter of the trees at the shoreline, boaters passed the day away with a variety of land activities too.

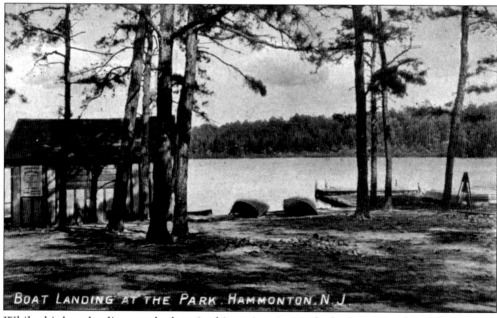

BOAT LANDING AT THE PARK. HAMMONTON. N. J.

While this boat landing stands alone in this setting, it was the busiest area of the lake grounds for almost nine months of the year. The townspeople brought picnic lunches, books, and banjos to enjoy while boating in canoes and rowboats provided by the town.

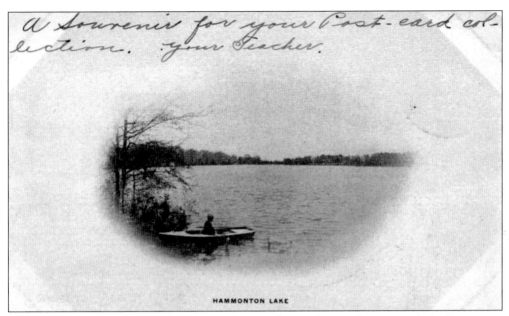

HAMMONTON LAKE

Postcards were even given to students by their teachers, whose influence on their charges was profound, demonstrated by this example. Sent in 1905, this handwritten inscription, "A souvenir for your post card collection. Your Teacher," suggests that children hoarded postcards as today's kids collect baseball cards. This postcard has survived over 100 years.

VIEW OF LAKE, HAMMONTON N.J.

Who cannot picture standing at the shore of Hammonton Lake enjoying the peace of the day? Here a lone canoe awaits its passengers and is moored to a temporary but safely constructed dock. Across the water is the government-protected wild bird preserve complementing the mood of the scene.

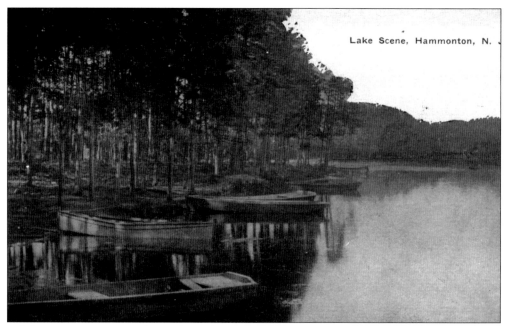

Lake Scene, Hammonton, N. J.

While canoeing was popular in the early 1900s, rowboating came in as a close second, giving people a bit more leeway for movement without the nagging fear of overturning. During early hours, rowboats and canoes were seen all along the water's edge. During the day, however, they were employed on the lake, manned by happy park visitors.

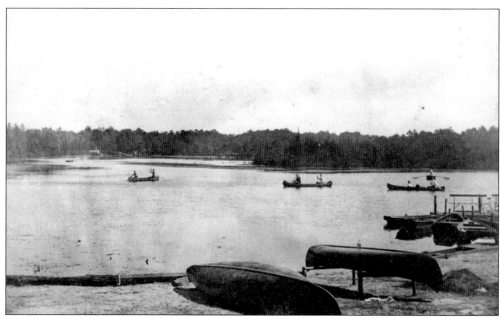

Canoeing was a favorite pastime in 1927. Weekends found the lake strewn with canoes during all the seasons of the year except when it was frozen. In the summer, group canoe outings were regularly scheduled as family or club special events.

22. *The Lake, Hammonton, N. J.*

This peninsula houses the William Smith Conservation Area. In an 11th-hour move, owner Gertrude Loveland personally appeared at Trenton, the state capital, when local school and town authorities planned to assume her acreage for a new school by eminent domain. She signed the papers deeming her beloved land as a bird preserve forevermore, named after her father, William Smith.

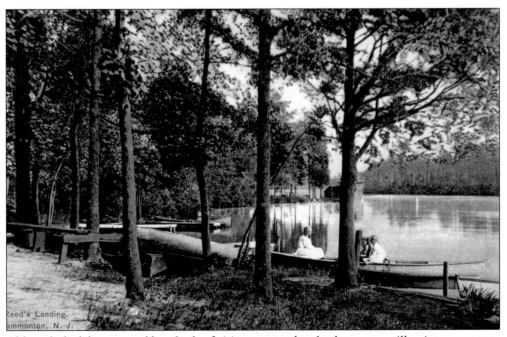

Reed's Landing, Hammonton, N. J.

Although the lake attracted hundreds of visitors on weekends, there were still quiet moments to steal during the off-hours. Longtime elderly resident Anna Dudley told this writer in the 1940s that ladies of her day loved to sit and languish by the water during rare lazy afternoons.

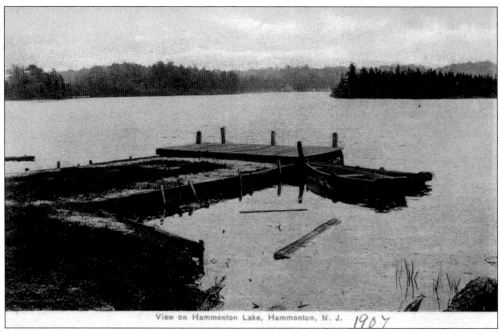

View on Hammonton Lake, Hammonton, N. J. *1907*

This early scene demonstrates the lake's humble beginnings. Still in its unspoiled state, the boat and dock were present for practical purposes, navigating the water only when necessary, thus explaining the staid, no-nonsense condition of the dock. The community had not yet recognized the park's social or health importance for its residents and tourists, but that would soon change.

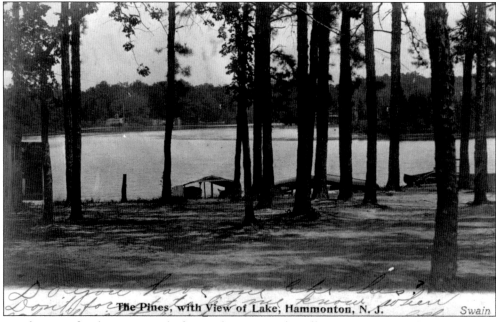

The Pines, with View of Lake, Hammonton, N. J. *Swain*

For those confined to areas void of natural greenery, the tall, towering pines of southern New Jersey offered a welcome change of scenery. "They take my breath away," this vacationer wrote. "I feel so alive among the pines." On a more practical note, the evergreens also indicated loamy soil perfect for farming or gardening.

The underdeveloped lake boasted health claims that drew droves of ailing patients in the 1800s. They bathed in the springs and drank the water. Numerous cures went "on record." One pamphlet referred to the incredible improvements of kidney stone patients. This area known as the Chalybeate Spring provided a continuous flow of water, attracting scores of visitors.

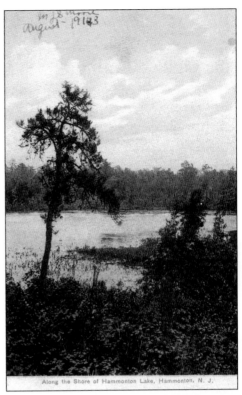

Along the Shore of Hammonton Lake, Hammonton, N. J.

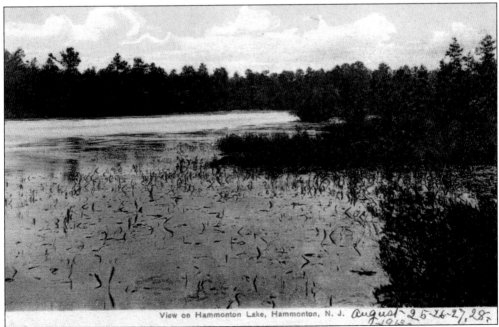

View on Hammonton Lake, Hammonton, N. J.

The lake's unkempt appearance seen here is explained by its original intended use. It was created to simply dam up waters from a nearby stream to flood areas of cedar tree stumps, left behind by the lumbering industry, already situated in that space. It was an industrial move that unintentionally created a main tourist attraction for the town.

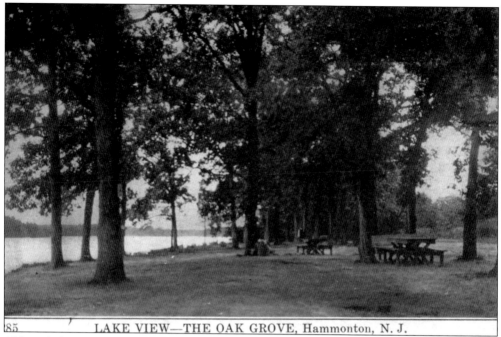

85 LAKE VIEW—THE OAK GROVE, Hammonton, N. J.

Although the pines drew the media and marketing attention, lake enthusiasts also celebrated the fine oak trees that offered the true shade at the park. A colony of artists took up Central Avenue residences within walking distance of the park and were often seen on its grounds capturing the beauty of those trees on canvas.

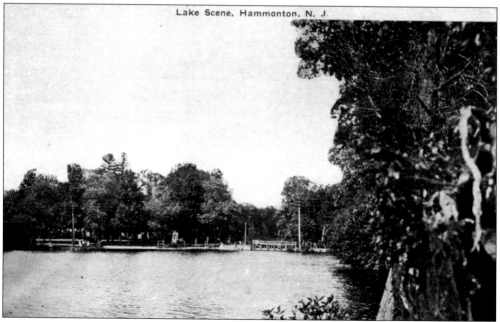

Lake Scene, Hammonton, N. J.

Thick, twisted, and melded trees jut out onto the lake from the peninsula, a 15-acre tract set aside by state mandate as a bird preserve. It is there that wildlife has found sanctuary since the early 1900s. Birds enjoy the berries and thistles offered by the trees and bushes, but all wildlife finds protection in that beautifully dense forestland.

94

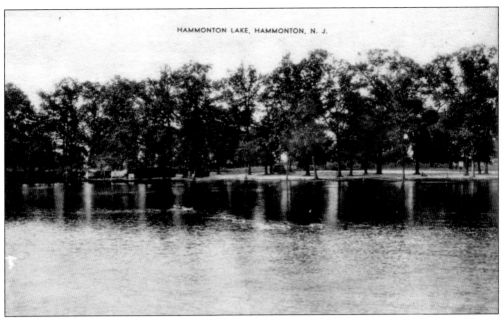

Although Hammonton Lake's grounds were cleared for a lake beach, the early settlers could not bring themselves to entirely devoid the space of trees. They valued the shade as protection against the sun's afternoon rays and saw beauty in the grounds hosting many fully grown maples, oaks, and white birches. Their reflections on the shimmering water presented a picturesque shoreline view.

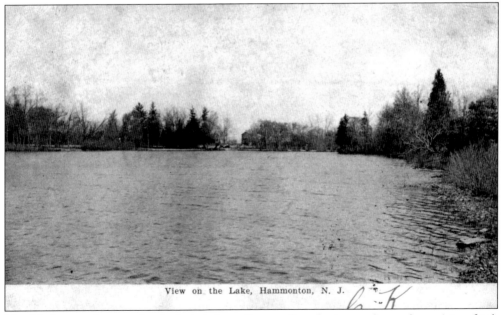

The lake's natural vegetation included dense forests of scrub pine, cedar, and a variety of oak trees, including red oak, jack oak, and bear oak, with some birch and red maples. The forest floor hosted swamp alder, sweet pepper bush, and magnolia. This woodsy collection exists today according to a 2005 New Jersey Department of Environmental Protection survey by Kathy Sedia of Richard Stockton College.

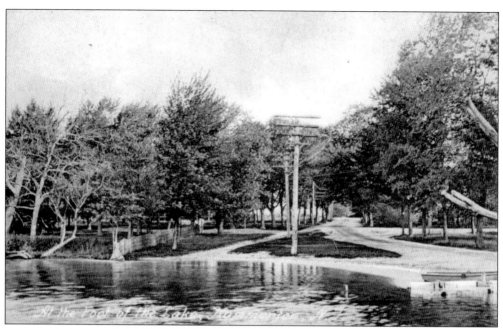

Tree trunks have been allowed to grow at will, leaning in unison toward the sun. The foot of the lake was also given to Mother Nature's will, with no substantial boundary to constrain it. Natural landscaping was favored and allowed to flourish, resulting in a long-ago scene that may still exist today in that section of the park.

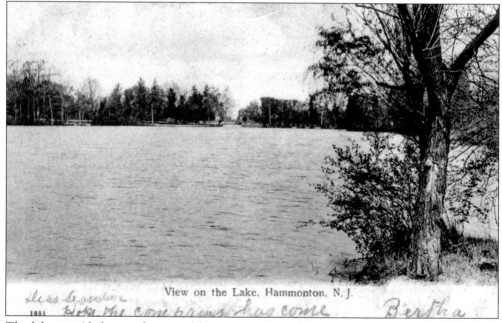

View on the Lake, Hammonton, N.J.

The lake provided space for several businesses. One of the most unique was C. F. Fowler's machine shop. In 1889, it was reported that he was designing a machine for baker shops that prepared raw dough for baking and then baked it too. He also manufactured the Hammonton Brooder for chicks, which was the mainstay for area poultry farmers.

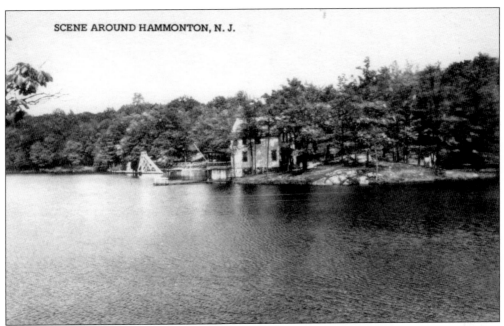

This boathouse solved a park purpose. After the lake became an established community entity, it was decided someone needed to watch over the lake 24 hours a day, so it was refurbished as a groundskeeper's quarters. The park remained free of vandalism and nasty incidents under that system.

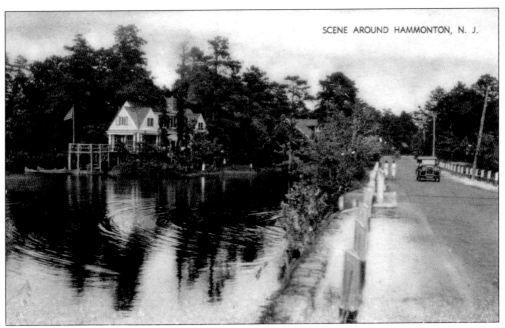

Residences fronted up along the lake's shore. Because of its water's scenic value and tonic benefits, real estate in that area was considered prime property, commanding a premium price. Accordingly, the affluent lake dwellers built fashionable permanent homes instead of tiny lakeside houses meant to serve as summer getaways.

Built in the early 1960s, Kessler Memorial Hospital overlooks Hammonton Lake, offering many patients a placid view from their hospital room windows. The Hammonton Chamber of Commerce sponsored this card, touting the lake's boating, swimming, fishing, and playground facilities on the reverse side.

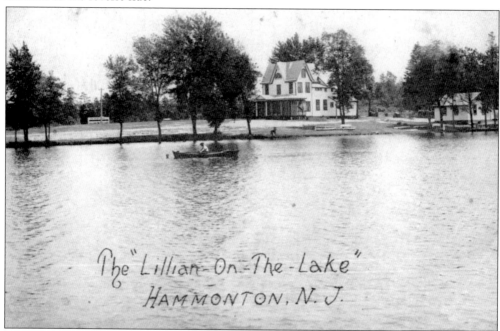

The Lillian on the Lake was a large gathering place for local parties, weddings, and banquets. For years, the Petkevis family offered delicious home-cooked fare. The Lillian drew so many guests, events had to be booked months in advance, circumstances not common in a small town of the 1940s.

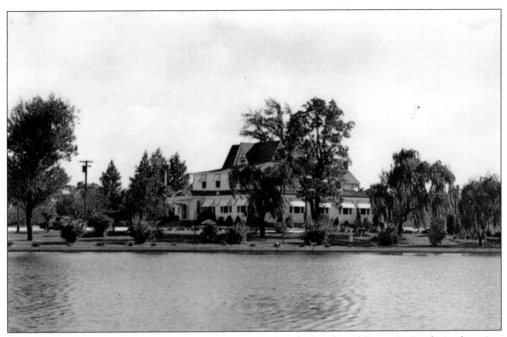

The Lillian on the Lake was the favorite banquet facility for local weddings. By its choice location along the picturesque waters of Hammonton Lake, the Lillian provided a natural backdrop for wedding photographs. Colorful landscaping completed the ambiance.

River bush dot the lands surrounding Hammonton Lake. What is referred to as underbrush actually is an enchanting display of natural greens indigenous to the pinelands, such as mountain laurel, inkberries, wild strawberries, and huckleberries. Seedlings are still plentiful, ensuring the forest's proliferation.

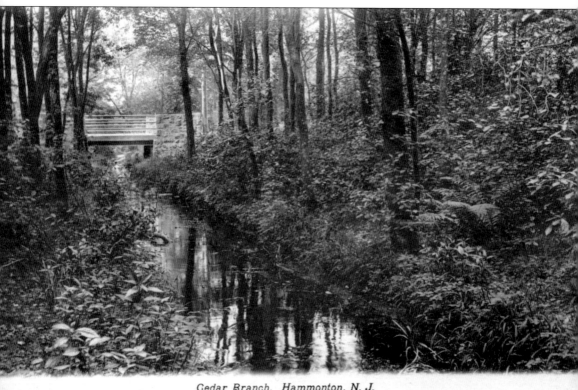

Cedar Branch, Hammonton, N. J.

A full population of cedar trees is indigenous to this area, growing right up and into the water. The Hammonton Lake area held a full bounty of cedar groves all through its grounds even before the lake was forged. The lumber industry prevailed on the cedar tree, recognizing its unique quality of expanding when wet. Consequently, cedar became the preferred housing material for roofing and siding, designed by nature to keep homes dry from rainfalls. Although great, the demand never outweighed the local supply. Cedar was normally left in its natural state, another bonus to its useful properties. So hardy are the cedar trees, many area streams carry a yellow hew from the cedars' roots blanching into the water. Even today, cedar water is so common that bathers wear old suits when swimming in untreated streams, as it turns their swimming gear a characteristic cedar yellow.

Six

A PLACE TO REFLECT

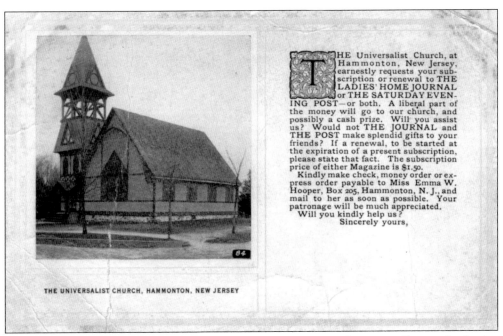

THE Universalist Church, at Hammonton, New Jersey, earnestly requests your subscription or renewal to THE LADIES' HOME JOURNAL or THE SATURDAY EVENING POST—or both. A liberal part of the money will go to our church, and possibly a cash prize. Will you assist us? Would not THE JOURNAL and THE POST make splendid gifts to your friends? If a renewal, to be started at the expiration of a present subscription, please state that fact. The subscription price of either Magazine is $1.50.

Kindly make check, money order or express order payable to Miss Emma W. Hooper, Box 205, Hammonton, N. J., and mail to her as soon as possible. Your patronage will be much appreciated.

Will you kindly help us?

Sincerely yours,

THE UNIVERSALIST CHURCH, HAMMONTON, NEW JERSEY

Postcards served many purposes in their heyday. Some were sent by nonprofit organizations as funding tools. This one is specifically soliciting magazine subscriptions as a means of gathering funds for the Universalist congregation. Its minister, Rev. Asher Moore, began preaching in 1858 at the schoolhouse of Old Hammonton, eight years before the congregation's formal establishment. It was a humble but significant beginning.

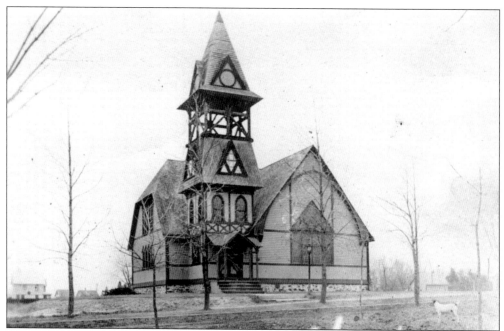

On December 1, 1864, the Universalist Social Circle members began meeting at the home of Mrs. H. T. Pressey. In 1876, Rev. M. Ballou from nearby Atco assumed the tiny congregation. In 1887, this building was erected and later sold to the Episcopal Church in 1923.

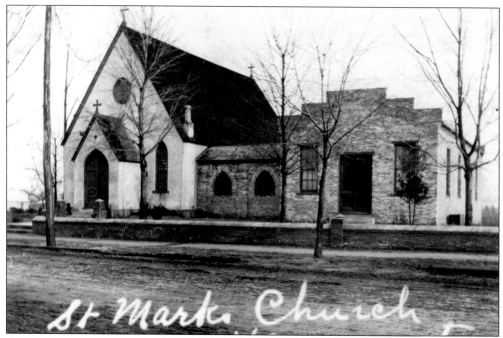

Originally St. Mark's Episcopal Church was located on Route 54, known locally as Twelfth Street. When it was moved to the original location of the Universalist church at Peach and Third Streets, the small brick side building was left behind, later housing a car-repair shop, and has since been demolished.

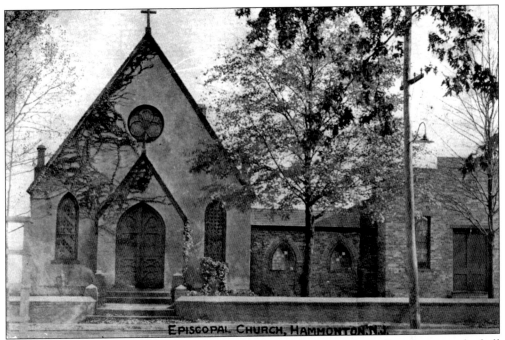

Once moved from this location and attached to the existing Universalist structure, the bell tower was shortened during a much-needed extensive restoration under the supervision of Rev. Francis James Chipp in the 1940s. The major project that included a new roof was given to local contractor Clarence "Reds" Foster.

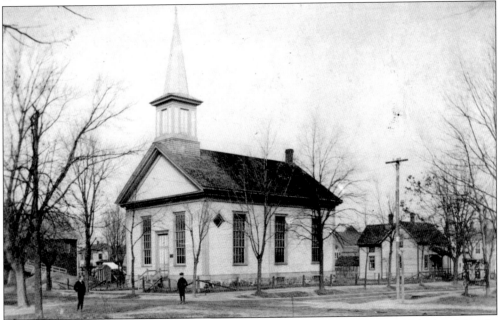

The Baptists initially began practicing their faith in individual homes. Then the local Baptist Church was officially formed in 1859, meeting at Elvins' Store. The church building was constructed on Bellevue Avenue in 1863, a few doors from the Hammonton Methodist Church, and in 1885, it was moved to Third and Vine Streets, where it stands today.

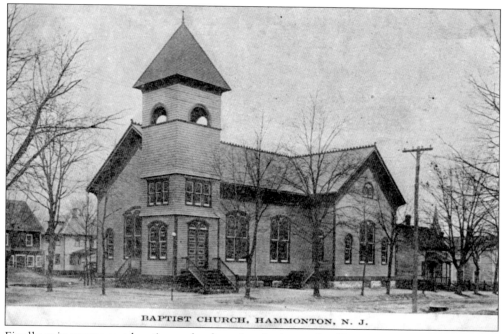

BAPTIST CHURCH, HAMMONTON, N. J.

Finally at its permanent location and enlarged to fit the needs of its growing congregation, the Baptist Church was placed under the guidance of Dr. Kempton. In 1887, Rev. C. M. Ogden assisted the ailing Kempton, managing to double the 1885 membership that had originally necessitated the larger church.

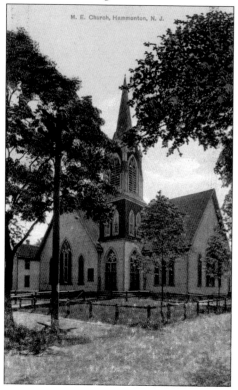

M. E. Church, Hammonton, N. J.

For a time, an iron ornamental fence surrounded the Hammonton Methodist Church. It was said it was prematurely removed when one of the early pastors objected to having a barrier around his church. He wanted it to be easily accessible from all sides so prospective church members would feel welcome to walk in without having to find the formal path.

This is one of the first likenesses of the Hammonton Methodist Church. Still at its Bellevue Avenue and Vine Streets location today, its stained-glass windows and bell tower are perpetually reassuring presences of spirited longevity. A group of its congregation's members obligingly posed for this photograph.

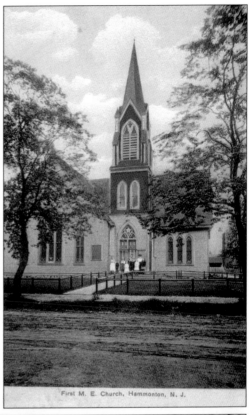

First M. E. Church, Hammonton, N. J.

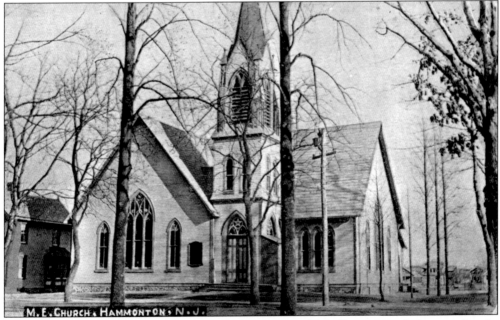

M. E. CHURCH, HAMMONTON, N. J.

Around 1920, it was discovered that the Methodist church's bell tower needed restoration. In the process of renovation, the tower lost five feet and its cone-shaped roof, resulting in a change of its exterior appearance.

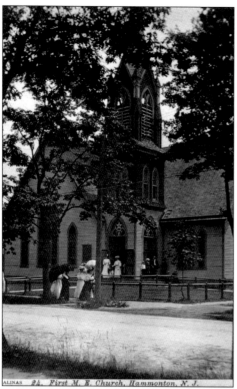

Ladies in their Sunday best, some carrying parasols, gather for services. The Methodist church was built in 1890 of timbers and beams from its original structure in Old Hammonton. The meeting room format changed in 1945 when an altar was placed in its center with a divided chancel rail and a lectern and pulpit on either side.

ALINAS 24. First M. E. Church, Hammonton, N. J.

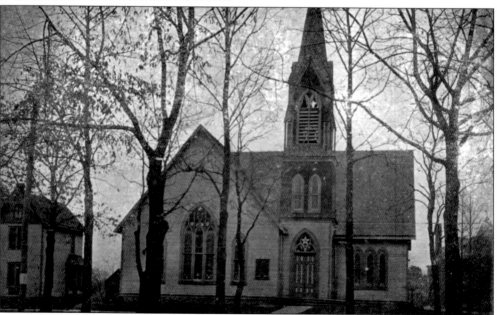

It was discovered in the 1970s that only an intent to incorporate was filed by Methodist Church officials sometime between 1861 and 1887. The situation was rectified over 100 years later when the church incorporated during Rev. Francis Patterson's tenure. He also spearheaded a basement dug by his church members, providing space for a kitchen, Sunday school classes, lavatories, and special events.

The Presbyterian Church began with nine members at a local mission station. In 1861, Rev. F. R. Brace held services at Black's Hall. Later the small congregation began meeting at the new Baptist church in Old Hammonton. In 1878, the group had this handsome church as their own.

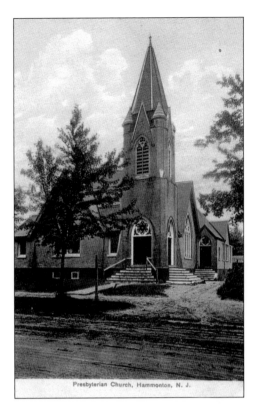

Presbyterian Church, Hammonton, N. J.

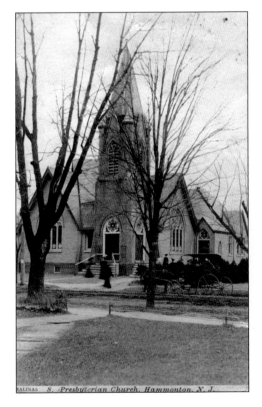

8. Presbyterian Church, Hammonton, N. J.

It was observed in the 1889 *Illustrated History of the Town of Hammonton* by H. W. Wilbur and W. B. Hand that the Presbyterian Church of Hammonton had "quite a cosmopolitan character in a small way." Again Hammonton's natural inclination toward big-city ways was observed about 10 years before the 20th century by two of its own.

Located directly beside St. Joseph Church on North Third Street, the rectory was a finely built home-style residence housing the presiding order of Palatine Fathers. It was the center of activity, hosting parish offices and committee, society, and staff meetings.

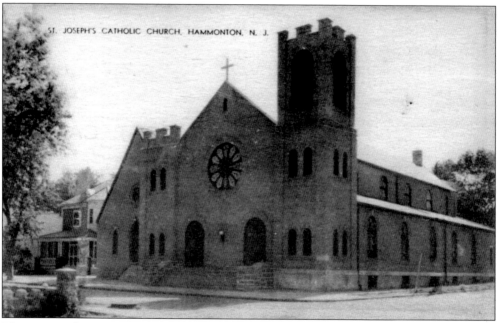

The section of St. Joseph Church bearing the cross was the main church. The smaller section to the left of the cross was the original, used at the time of the photograph as a chapel for overflow masses whenever needed, such as on Easter Sunday. To the left of the church is the rectory. All these buildings have since been demolished.

The Lady of Mount Carmel was placed in the highest niche of the original church altar. The Italian immigrants began a modest festival in her honor on July 16 on Pine Road in the 1800s. It grew to over 60,000 participants in the 1950s and is still held today under the watchful eye of the Mount Carmel Society members. Pictured here is Our Lady of Mount Carmel as she stands today in St. Joseph Church.

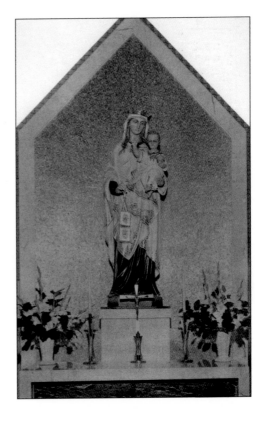

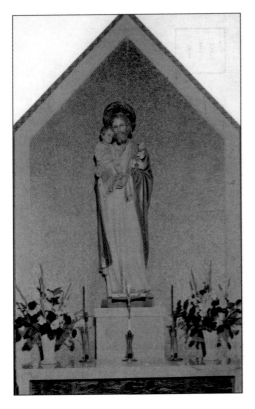

A new, modern design, St. Joseph Church was built in the 1960s. The background of this grotto is laden with gold mosaics all set one by one by expert craftsmen. St. Joseph stands here at the right of the altar.

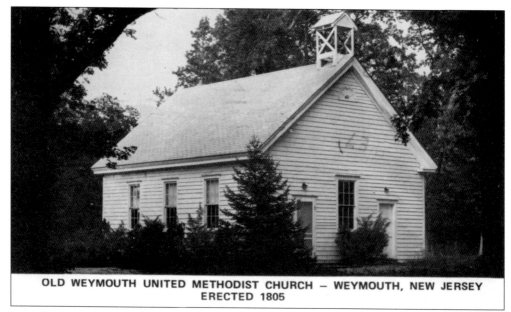

OLD WEYMOUTH UNITED METHODIST CHURCH — WEYMOUTH, NEW JERSEY
ERECTED 1805

Even though Hammonton proper boasted churches of all denominations, some other communities within the town limits preferred to form their own congregations in their sections no matter how small. Here a charming church building with a modest bell tower was home to the Weymouth Methodist community.

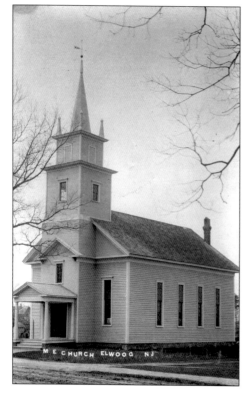

This picturesque Methodist chapel within Old Hammonton limits was the home of the Elwood Methodists. Congregations wished to worship with family and friends in churches close by. Traveling by horse and wagon over miles of unpaved roads was not acceptable to this group, so it maintained its own separate congregation.

Seven

A Place to Remember

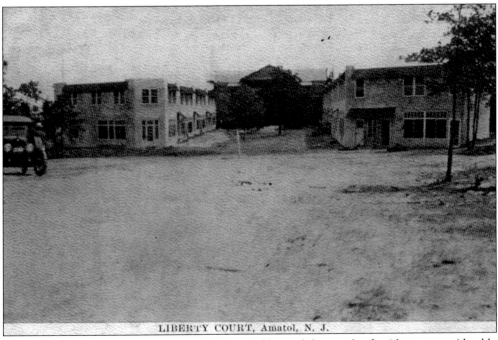

LIBERTY COURT, Amatol, N. J.

Two miles away, the vast company town of Amatol housed thousands of residents, a considerably larger population than Hammonton proper at that time. It boasted police and fire departments, a waterworks that delivered 17 million gallons a day, a sewer plant, a 950-seat movie theater, gourmet restaurants, and modern shops. The community was governed by a town superintendent in charge of maintenance and operations.

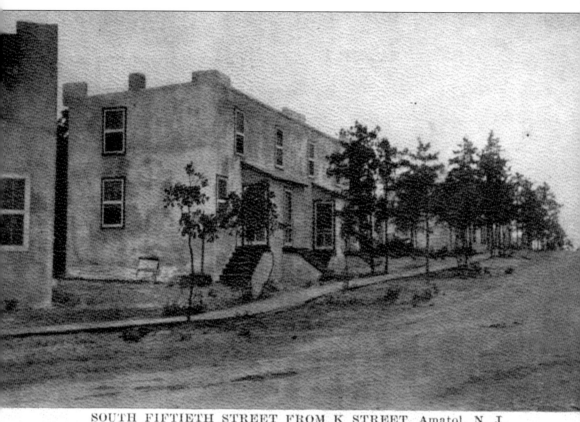

SOUTH FIFTIETH STREET FROM K STREET, Amatol, N. J.

Once a young, bustling community within Hammonton's city limits, today Amatol is a ghost town with tales of its existence waning as the children of its era pass on. One building remains on the White Horse Pike that housed the New Jersey State Troopers for years until their recent move to new headquarters.

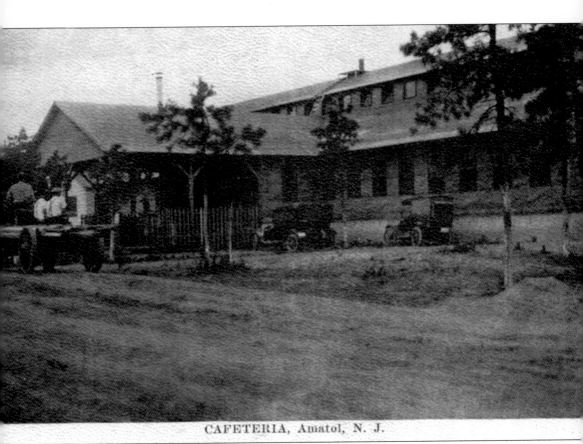

CAFETERIA, Amatol, N. J.

Workers received $100 a month or more for a full week of work. Needless to say, most blue-collar workers flocked to the employment department, leaving the Hammonton industries looking for replacement workers. Although excellent specialty restaurants existed only two miles away in the company town, employees also enjoyed exceptionally fine food at this plant cafeteria.

Amatol (named after the combination of ammonium nitrate and TNT) was a bomb-making facility built by the government in East Hammonton in 1918. This mess hall accommodated thousands of workers. The plant was proud of the high-caliber gourmet food that was prepared and served to its employees.

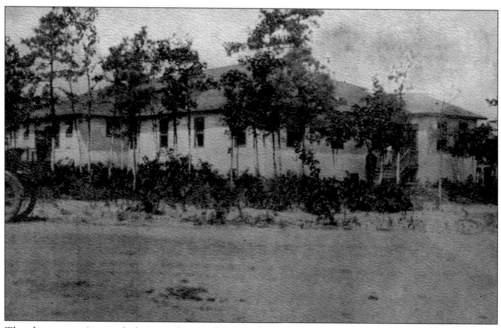

The plant executives took their meals away from the workers in a smaller facility where every amenity possible was provided. The project managers planned Amatol as a totally self-sufficient operation. Workers and their families did not need to leave the area to shop, dine, or find entertainment. Even a movie house was included, all designed by the country's leading architects.

A community swimming pool at Amatol was considered an incredible perk for that era. The federal government spared no expense when planning this installation. The plant's workers were paid well and treated with respect and dignity. Their families were happy and satisfied, often spilling into Hammonton's downtown for an outing.

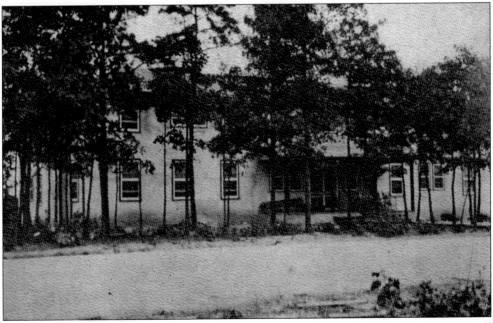

A dormitory with pristine accommodations was built to house single workers. It was well ventilated with brightly painted walls, comfortable beds, and all the conveniences of the times. The executives believed that providing the best of everything for their workers resulted in a greater product output, and in the end, they were proven right.

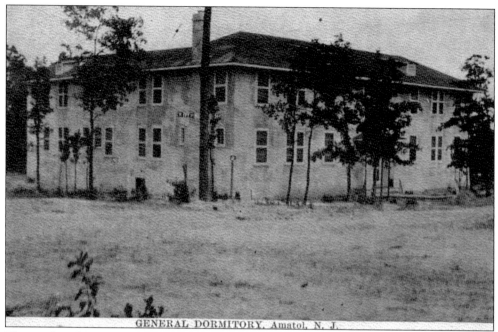

GENERAL DORMITORY, Amatol, N. J.

The workers felt safe sleeping in the plant dormitories. All buildings working with explosives on the grounds were expertly designed to blow upward rather than outward if ever an explosion occurred, leaving all other plant buildings free of jeopardy.

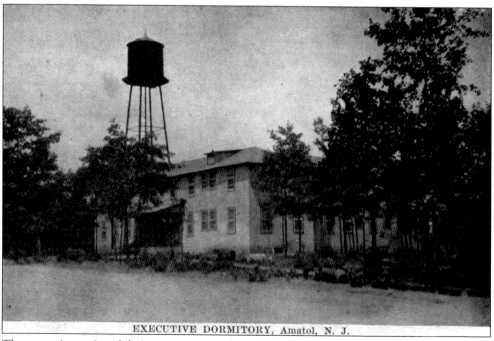

EXECUTIVE DORMITORY, Amatol, N. J.

The executives enjoyed their own quarters where they slept when multiple shifts were necessary. The plant's output capability was reported as 75,000 seventy-five-millimeter shells loaded daily as well as 60,000 smaller shells. The dormitories served as rest areas during the extra hours sometimes required.

Eight

A PLACE FOR EVERYTHING ELSE

It is clearly evident that this worker has formed a comfortable bond among the residents of the chicken coop at the Collinses' Bellevue Avenue farm. While the Collins family later went on to strictly maintain a fully working dairy farm at the same location, chickens also provided income in earlier years. The Collins Dairy ceased operations in the late 1960s.

In 1889, there were approximately 25 poultry farmers in Hammonton. They ranged from a few hundred chickens to thousands. Harry M. Phillips, the largest poultry business, had over 7,000 chicks, and J. C. Browning maintained nearly the same size range. They hatched, raised, and sold broilers, a chicken raised for its meat.

Truck farming was the area's major source of income in the 1800s, earning New Jersey its nickname, the Garden State. Hammonton hosted a Fruit Growers Association auction where farmers brought their crops daily and received the price of the day. Temporary workers lived in camps, while town residents, especially school-age children, supplied the bulk of the workforce.

Farms provided the main source of livelihood and employment in the early years. A worker tends to a field of bean plants, some reaching up to eight feet, as seen here. Until the 1960s, local teenagers worked in the fields during their summer vacations from classes.

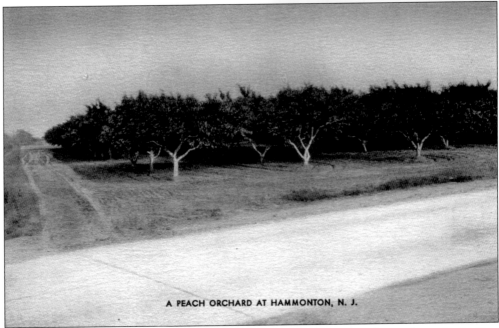

A PEACH ORCHARD AT HAMMONTON, N. J.

To market their peach crop in the 1940s, Hammonton leaders organized a peach cavalcade. Cars were led in procession style into the local peach orchards by area dignitaries to view the sea of delicate pink peach blossoms. In one field, a peach queen, crowned at the annual May Hop, greeted the visitors with peach blossom twigs.

End View of Flying Pen, Hammonton, N. J.

Unusual hobbies turned into opportunities for residents to earn pin money. A deerskin tanner, butter mold carver, and several cut-glass artisans working in garages and basements honed their talents. Here a pigeon enthusiast keeps his flock. Goats, rabbits, and various barnyard animals were also raised to sell.

Seeing Hammonton, N. J.

Copyrighted 1907, by Tichnor Bros., Inc.
Pat. applied 1or.

This unusual postcard, featuring a busload of sightseers, provides a space for a message when opened. The front grill of the vehicle is a small folded sheet that flings open to reveal 23 scenes of Hammonton, all postcard images featured among these pages.

120

FROM HAMMONTON, N. J.

Novelty postcards were all the rage in the 1800s, and Hammonton was not immune to their charm. This beautiful rose carrying the greetings was embellished in fine-grade glitter. A faux frame was added as a finishing touch.

Some cards were designed to be framed as miniature works of art. These violets were dusted with a thin layer of fine glitter. Roses fill in the border to add more whimsy. Such artistry was popular during these times.

This novelty card is a combination of fantasy and photographs. Four scenes are featured, including Bellevue Avenue, the People's Bank and Trust Company of Hammonton, the Pennsylvania Railroad station, and the high school buildings. It was said a debate ensued as to why the lake was not included, but whatever the reasons, it remained excluded.

Gazebos were Victorian homeowners' favorite addition to their yards, where families of that era spent much of their time. Hammonton was abundantly endowed with such structures of all sizes and shapes. Even public buildings added large versions of the gazebo, defined at that time as an exhibition area.

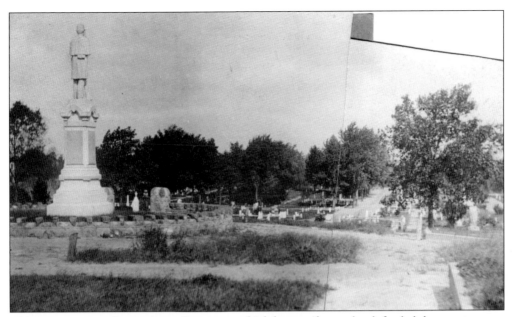

This monument at Greenmount Cemetery, which honors those who defended the country, was erected in September 1865. It still stands at the top of the hill in the center of the grounds where wreaths are laid each Memorial Day and Veterans Day. In the 1940s, schoolchildren used the hill for sledding on snowy winter days.

1. HAMMONTON PINES, HAMMONTON, N. J.

Hammonton is located in the heart of the famed Pine Barrens, known for its healthy air, therapeutic water, and generally restful atmosphere. Two dogs lounge in a well-trodden path among the tall pines of Hammonton. Through the government-protected Wharton Tract and wild bird preserve at the lake, pine trees are assured a place in the landscape forevermore.

Victor Moore was one of the actors who performed regularly with the local theater-arts group, along with his cousins, the Coogeys. He went on to become a nationally known movie actor but never forgot his Hammonton roots. Moore returned to Hammonton several times to visit family and friends and took part in the local theater productions.

The Eagle Theater was one of the earliest theaters in Hammonton, the first to make its mark as a memorable structure for the arts. Live productions were presented there and were by no means shabby attempts. The performances were of professional quality as were the costumes stitched by Hammonton's talented seamstresses of the times.

These costumes were quite elaborate for a small town's live theater production, where one might think money for such frivolous events was hard to come by. However, the New England settlers were avid theater buffs, forming a theater group years earlier even before the town was officially chartered.

People enjoyed having their photographs reproduced on postcards to send to their friends and families, possibly a forerunner of present-day picture Christmas cards. Here two women enjoy a photograph album with their two young companions. This may have been a family portrait of a grandmother, daughter, and granddaughters.

Lining up and smiling for the camera was a familiar pose in photography's infancy. Five companions felt this day was so memorable that a photograph was needed to commemorate the occasion. The background indicates it was snapped inside a formal studio.

Clara Cathcart identified these two lovely ladies, all decked out in summer white dresses, as Viola and Pearl Adams. On the reverse side, Cathcart further describes them as teachers. Also the publisher printed, "Post Card, Atlantic City Souvenir," indicating this was taken during a summer outing at the shore.

This beguiling family portrait featured on this card is identified as "Nina Jones, daughters Ruth and Margaret." Nina sent this to a friend thanking her for remembering her birthday when no one else did. She also referred to her own daughter Ruth.

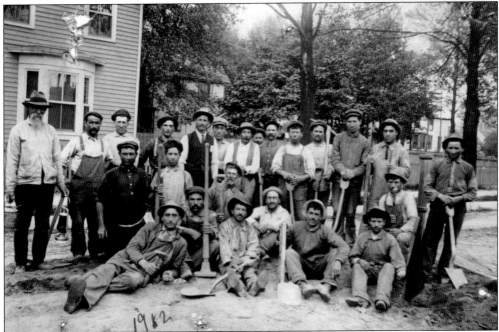

Manual laborers were plentiful in early Hammonton. They were men who looked for a full day's work. Members of this 1912 work crew stand proudly with their shovels, confidently staking their claim to their work ethic—a good day's work for a good day's pay.

ACROSS AMERICA, PEOPLE ARE DISCOVERING
SOMETHING WONDERFUL. *THEIR HERITAGE.*

Arcadia Publishing is the leading local history publisher in the United States. With more than 3,000 titles in print and hundreds of new titles released every year, Arcadia has extensive specialized experience chronicling the history of communities and celebrating America's hidden stories, bringing to life the people, places, and events from the past. To discover the history of other communities across the nation, please visit:

www.arcadiapublishing.com

Customized search tools allow you to find regional history books about the town where you grew up, the cities where your friends and family live, the town where your parents met, or even that retirement spot you've been dreaming about.